IMAGES
of Rail

ALASKA'S TANANA VALLEY RAILROADS

IMAGES
of Rail

ALASKA'S TANANA
VALLEY RAILROADS

Daniel L. Osborne

ARCADIA
PUBLISHING

ed by Arcadia Publishing
Chaᵣeston, South Carolina

Printed in the United States of America

Library of Congress Control Number: 2013933260

For all general information, please contact Arcadia Publishing:
Telephone 843-853-2070
Fax 843-853-0044
E-mail sales@arcadiapublishing.com
For customer service and orders:
Toll-Free 1-888-313-2665

Visit us on the Internet at www.arcadiapublishing.com

This book is dedicated to Candy Waugaman, whose generosity and wonderful private collection of Alaskana has made this book possible.

CONTENTS

ACKNOWLEDGMENTS

I gladly acknowledge Candy Waugaman, Nicholas Deely, Michael Nore, Nick Sheedy, and others who helped by allowing me to use their private collections in the creation of this book. My wife, Rita, helped in many ways, including research, encouragement, and proofreading. My friend Bill Stringer helped with encouragement, language, and accuracy.

 This book has been written for the Friends of the Tanana Valley Railroad Inc. That non-profit organization is keeping the history of the Tanana Mines Railway and the Tanana Valley Railroad alive. It has been a pleasure and a labor of love to join in on the restoration and operation of TVRR Engine No. 1 and the creation of a Tanana Valley Railroad Museum with Friends of the Tanana Valley Railroad's all-volunteer members. The author's proceeds from the sale of this book will be donated to the FTVRR.

 Public collections used in this book are from the Archives and Manuscripts, Alaska and Polar Regions Collections, University of Alaska Fairbanks, Fairbanks, Alaska (UAF); Collections of the Dawson City Museum in Dawson, Yukon Territory, Canada; the University of Washington Libraries, Special Collections; the Alaska State Library, Wickersham Collection (ASL); the Keystone-Mast Collection of the UCR/California Museum of Photography, University of California Riverside (UCRCMP); and the Friends of the Tanana Valley Railroad (FTVRR).

INTRODUCTION

In 1902, very rich placer gold deposits were discovered in creeks near present-day Fairbanks. At that time, there existed only a few primitive trails and river routes in all of Alaska. Only the largest rivers provided dependable transportation, and then only when they were ice-free. Sometimes even in summer, low water or rapids prevented their use by steam-driven stern-wheeler boats. In winter, even small rivers could be used for transportation, but mainly only for personnel and lightweight freight pulled on sleds by dogs.

The usual "rush" that followed this discovery resulted in many rich small mining operations 20 to 40 miles from the nearest river transportation. The routes to the mines included miles of bog and wet tundra. Any digging into the vegetation mat that covered the frozen ground to make a wagon trail frequently revealed a frozen mixture of soils and water called permafrost. Once the permafrost started melting after the removal of vegetation, the water either ran away and left a hole or mixed with the soil to produce deep muddy ponds with icy bottoms.

Unlike the Klondike, the elusive placer gravels in the Fairbanks mining district were very deep under the frozen valley bottoms. Mining this kind of ground required heavy machinery, including boilers, hoists, and large pumps. This did not stop little collections of miner's cabins at the various diggings, which started to become tiny towns. At this time, Alaska grew almost none of its own food, and game soon became very scarce wherever miners collected. Trading posts were few and far between on the major rivers, with high-priced and limited supplies.

Getting the necessary machinery and supplies to the mines to make mining practical and economical required something better than a dog team, pack horse, or horse-drawn sled during the winter. In the early 1900s, that meant one thing: a railroad. And with money short, expenses high, and traffic low, that meant a narrow-gauge railroad.

Lawyer and entrepreneur Falcon Joslin, with his brother John, his nephew Wade, and his partner Martin Harrais, arrived on the scene with financial backing to build a railroad from the riverside port townsite of Chena to the creeks. The name Joslin picked for his railroad, the Tanana Mines Railway, hereafter TMR, stated it purpose in its name. Chena was originally established as a small trading post on the north bank of the Tanana River before gold was discovered where the Chena Slough joined the Tanana River. Chena was considered the closest point to the mines with dependable river transport. With the discovery of gold, Chena started to grow.

Joslin, a Klondike stampeder, while finding no gold, had "mined the miners" in Dawson, practicing law and investing in various enterprises in the Klondike region. From an earlier Yukon coal mine investment near Dawson, Joslin imported a small H.K. Porter 0-4-0 narrow-gauge locomotive, rails, and other equipment. Starting at Chena, Joslin's team and an expansive workforce for the time proceeded to build north toward the mines.

Joslin was monetary partners with Close Brothers & Company of London, the financiers who also financed the White Pass & Yukon Railway (WP&Y). The Close Brothers apparently kept a tight rein on the new Tanana Mines Railway, which may be why, very early on, Charles Moriarty,

who was in the employ of the WP&Y, became the chief engineer of the TMR. The headquarters of the TMR, in Chena City, included a two-story depot, a two-stall engine house, several smaller buildings, and a large riverfront warehouse. Several tracks were laid in Chena's Front Street, turning it into a rail yard. A turning wye was constructed a short way north of Chena, but the TMR never had a turntable.

Meanwhile, another trader, E.T. Barnette, had been forced off the stern-wheeler *Lavelle Young* when it ran aground in 1901, about seven miles upstream from Chena on the Chena Slough, trying to bypass shallow water in the main channel of the Tanana River. Originally called Barnette's Cache, it was closer by trail to the gold-mining areas, and thus in high water it provided a shorter path to riches. Barnette's Cache was soon renamed Fairbanks and could not be ignored by the railroad. So at a place simply called Chena Junction near the present-day University of Alaska-Fairbanks Experimental Farm fields, a wye was constructed. A branch was built east to Fairbanks, while the "main line" turned north into Goldstream Valley. Just north of the wye was Ester Siding, where a branch to the mines around the mining towns of Ester and Berry, below Ester Dome, was hoped for but never built.

About four miles north of the wye, the rails turned northeast into Goldstream Valley toward the gold-discovery towns of Golden and Cleary. The railroad continued past the new town of Fox and a few miles more to what became Gilmore, which was located on a slope above the confluence of Gilmore Creek and Pedro Creek, which formed Goldstream Creek. The railway ended at Gilmore, three miles short of Golden, having used up the available funds. The gold-bearing creeks radiated out from Pedro Dome, with the town of Golden south of Pedro Dome on a tributary of Goldstream Creek, closer to Fairbanks. The original location map of the railway showed the rails climbing above Golden, passing east around Pedro Dome, and descending off the north side into the vicinity of Cleary.

As the Joslin's Porter 0-4-0 was only intended for construction and light hauls, two larger locomotives, No. 50, a 4-4-0, and No. 51, a 2-6-0, were bought from the WP&Y. Most of the early rolling stock was purchased from that railroad as well, including a few flatcars that were delivered still marked for the Klondike Mines Railway, another cash-short railway, which had never taken possession of them.

Many of the best mines were in the Chatanika Valley, on the north sides of Pedro Dome. The final and best route for a railroad to get there was to the north of Fox over a ridge of Pedro Dome, 1,500 feet above Gilmore. To the north was the growing Cleary City, home of the richest diggings. In order to obtain more financing, the Close Brothers, who may have been reconsidering their huge investments in Alaska, were bought out. Knickerbocker Trust Company of New York sold bonds to refinance the company. The railroad was reorganized as the Tanana Valley Railroad, hereafter TVRR, with offices in New York City and the same general management.

With funds thus obtained, additional track could be laid and some of Joslin's dreams could come true. His writings and filed location maps indicate future routes to Ester, Cleary, and the Tenderfoot mining district, 50 miles east of Fairbanks, as well as grand plans to connect with the WP&Y or to Haines, Alaska, 500 miles away. Dreams aside, the Gilmore railroad track was rerouted and looped back from Gilmore, passing the Loop Roadhouse on a long climb up the southern ridges of Pedro Dome. The track, now high on a hill above Fox in its climb, crossed Fox Gulch on an impressive trestle, Trestle No. 5. It then proceeded over the summit, where the Elliot Highway crosses it today, and started a long decent to Olnes.

On the way to Olnes, the rails went down the side of a long northwesterly ridge. There, trains paused at a station called Ridgetop, which served two more rich mining areas. Passengers and freight for Vault, to the northwest, and Dome City, to the southeast, were exchanged here. Farther on, the tracks reached the Chatanika Valley floor and Olnes, from which they ran almost straight past the Little Eldorado station. At Little Eldorado, another gold camp, a station was also set up. From there, the rails went on to end at the new town of Chatanika. Once again, the tracks stopped just three miles short of the target, the growing town of Cleary. Chatanika became the final northern terminus for the TVRR, despite Joslin's grand dreams. He continually promoted

his railroad to be extended to other mining areas, to the coast of Alaska, or to a connection with the WP&Y by an extension to Canada, but it never happened.

After 1907, the railroad settled into profitable operation. Fairbanks had grown so much that the railroad was now considered to run from Fairbanks to Chatanika with a branch to the port at Chena City. Over the years, several additional second-hand locomotives were acquired as well as a storage battery driven Federal electric trolley car, sans trolley. However, the railroad seems to never have acquired a caboose or a real baggage car. The TVRR used heated boxcars for baggage cars. It appears that all trains ran as mixed trains ending with a coach.

World War I was hard on northern mining and the railroad. High war-driven labor costs put many mines out of business, curtailing the traffic on the railroad. Costs for supplies increased and the population declined, despite increased prices for raw minerals. The Fairbanks mining district was also facing a fuel-starvation condition. Wood, the principal source of heat and power, was in short supply, the whole local area having been extensively cut over. The nearest coal was south of Nenana and had been locked up by government order in 1906. A future government railroad was expected to build rails south from Nenana to the coalfields, but that could not save the Tanana Valley Railroad. By 1916, the TVRR, with its high expenses, was not making payments on its bonds and was declared insolvent.

After much political turmoil, a government-owned railroad in Alaska was authorized by Congress in 1914. The Alaska Engineering Commission (AEC) was formed to build from the coast of Alaska to a navigable river in the interior of Alaska. The TVRR was purchased by the AEC to be operated as a narrow-gauge branch. The AEC extensively rebuilt and upgraded the rails and actually extended them from a new station at Happy as a narrow-gauge operation, 60 miles southwest towards Nenana. Planning for the future, they laid that section with standard-gauge ties. There, the extension ended at North Nenana, across the wide Tanana River from Nenana, with its standard-gauge tracks already under construction, leading south to coal and the coast. In the open water season, freight was barged across the Tanana River, and in winter, narrow-gauge tracks were laid on the river ice so that freight and people could be transferred directly from standard-gauge to narrow-gauge equipment. This was unique, as not many railroads used a frozen river for their roadbed as a part of their normal operations.

Following the completion of the Nenana Bridge—now the Frederick Mears Memorial Bridge—across the Tanana River in 1923, the tracks were widened to standard gauge all the way to Fairbanks. However, the portion of track from Happy to Fairbanks, about 11 miles, was operated dual gauge, with its distinctive three rails. The Chatanika Branch, which ran northeast from Happy to Chatanika, remained narrow gauge.

On July 15, 1923, Pres. Warren Harding arrived to drive the golden spike at the north end of the Nenana Bridge. Exactly a month later, Hubert Work, the secretary of the interior, ordered what had simply been called the Government Railroad of the AEC to officially be called the Alaska Railroad. Falcon Joslin's dream of a connection to the coast finally came true, but too late for his dreams of riches.

By this time, the technique of "drift mining" began to become unprofitable for a variety of reasons, but there was still plenty of gold in the ground that could be mined by dredging. The United States Smelting Refining and Mining Company (USSR&M) arrived and constructed an extensive infrastructure of camps, power lines, and dredges that gave the Chatanika Branch a final burst of revenue. Trucks and better roads provided by the government-financed Alaska Road Commission were available by then. On the Chatanika Branch—the original TVRR narrow-gauge rails from Happy to Chatanika—revenues plummeted. There was small need for the little railroad, so the equipment was sold and the tracks were taken up in 1930. The former right-of-way from downstream of Gilmore to Fox was mined by the USSR&M's dredges, so little is left of that portion. Other sections of the old right-of-way can still be found, many of them on private land.

As part of its upgrading from narrow-gauge, the federal government bought a fine new Baldwin Ten Wheeler 4-6-0, which was numbered 152. This locomotive is still in operation today on the

Huckleberry Railroad in Flint, Michigan. Engine No.1, which was brought from the coal mine near Dawson, has been restored by the Friends of the Tanana Valley Railroad and is operated several times a year at Pioneer Park in Fairbanks. It seems strange that two locomotives from a relatively unheard-of and short-lived railroad with a small locomotive roster should be running 80 years after the railroad ceased operations.

One

THE STAGE IS SET

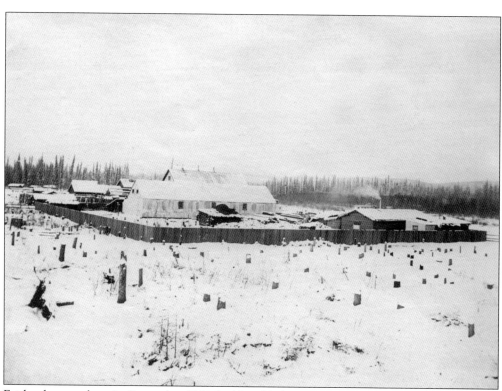

Fairbanks, seen here in September 1903, had humble beginnings as Barnette's Trading Post, but the nearby hills held tons of gold. Soon, the large Northern Commercial Company bought out E.T. Barnette. Northern Commercial was still in the same location until the early 1970s, anchoring the Fairbanks downtown district. (Waugaman, 12-02-26_0035.)

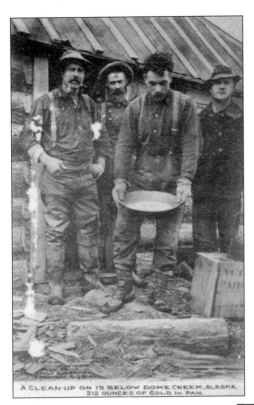

A CLEAN-UP ON 19 BELOW DOME CREEK, ALASKA,
212 OUNCES OF GOLD IN PAN.

This photograph is an example of what the whole railroad was about: miners with pans full of gold. The trick was to somehow get the gold out of the ground. That trick took heavy machinery and supplies, which required a railroad to transport them. (Waugaman, 12-02-26_0010.)

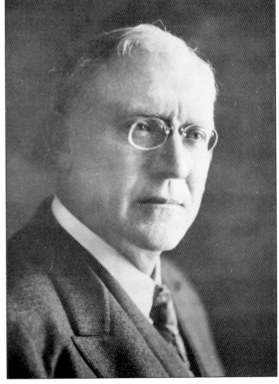

Falcon Joslin (1866–1928), the founder of both the Tanana Mines Railway (TMR) and the Tanana Valley Railroad (TVRR), made his fortune at Dawson in mining, utilities, fuel, real estate, loans, and insurance during the Klondike gold rush. Joslin soon had money to invest in numerous enterprises in the Yukon, including coal-mining operations. The Coal Creek mine, 40 miles down the Yukon River, was his stepping stone to the Fairbanks gold fields. (Joslin collection, UAF 1979-0041-0448.)

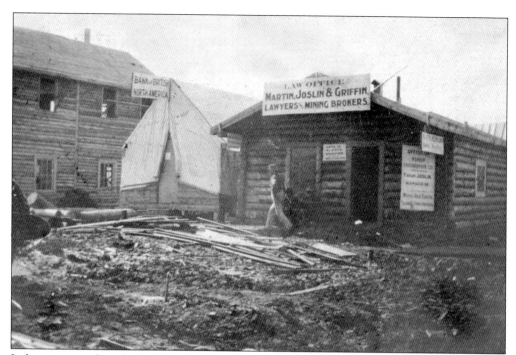

Joslin came north to find gold in the Klondike, but he found it more lucrative to continue using his skills as a lawyer. His office, near Queen Street in Dawson, Yukon Territory, is seen here. He appears to have been doing better than the Bank of British North America next door in the tent. (Joslin collection, UAF 1979-0041-0438.)

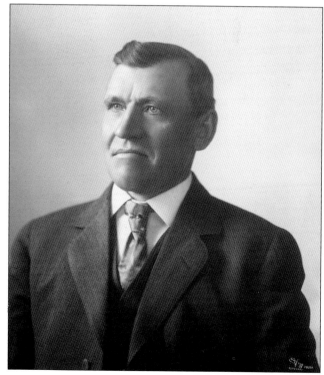

Martin Harrais (1865–1936), Joslin's partner in the TMR, started the town of Chena as the railhead, as Fairbanks was not considered a good port. He was the construction contractor for the TMR, built the Chena Lumber and Light Company, and sold town lots. The railroad was to tie his town to the gold mines. He invested his $80,000 Klondike fortune into the town of Chena. (UAF, 1964-07190, M. Harrais, 683C.)

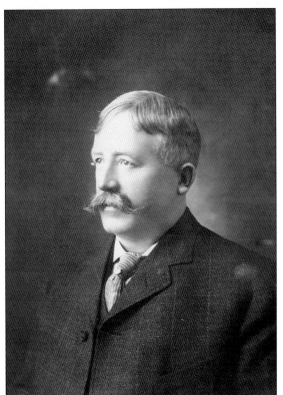

Charles Moriarty (~1864–1908), the superintendent of the TMR, had been the superintendent of the White Pass and Yukon Railway (WP&Y) and was known as the Snow King. Since both the WP&Y and the TMR were financed by the Close Brothers of London, they may have required him to be superintendent as a condition of funding, since Joslin and Harrais had limited railroad experience. (Joslin collection, UAF-1979-0041-0053.)

The town of Chena had various spellings—Chenoa was just one. This 1904 image shows the rush for the Tanana diggings. These passengers, having landed from the steamer *Rock Island* at Chena, stand on what became the docks and right-of-way for the TMR. The street behind them was later home to the TMR tracks. (Waugaman, 12-01-0015.)

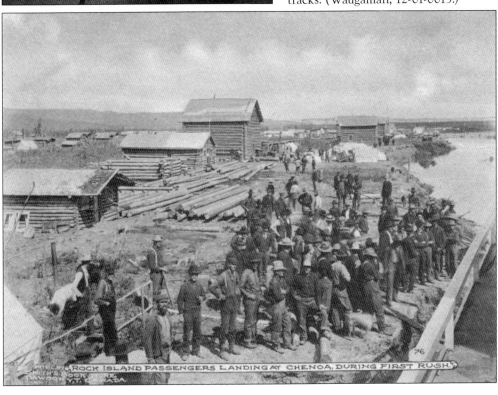

Chena City was pinned between Chena Ridge and the Tanana River. Most of the housing was across Rost Creek via various bridges, this being the best one. Chena's entire business district—Front, First, and Second Streets—was across the creek, except for the Chena Mill, which was built years later. (Waugaman, 12-02-26_0041.)

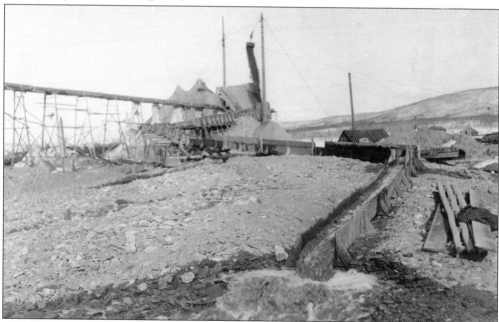

An ore bucket dumps from a gin-pole rig. Mining in the Fairbanks gravels, between 100 feet and 200 feet deep, was different than the shallow diggings of the Klondike. This necessitated dropping a shaft through frozen and unfrozen mud, dirt, gravel, sand, and water or ice. Once on "pay," drifts were dug horizontally and the gold-bearing soils were placed in dumps to be sluiced during the summer. (Waugaman, 12-01_0024.)

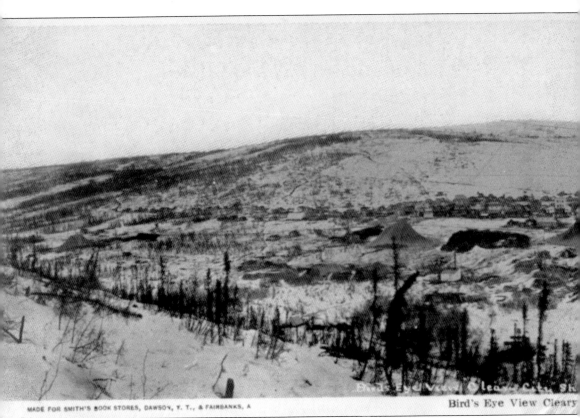

Bird's Eye View Cleary

Cleary City, which reached a population of 1,100 in 1907, started as a simple collection of log cabins. The hand-dug shafts, with their telltale piles of both pay and spoil, soon grew. The need for more efficient transportation of mining equipment and wood for fuel was a driver for a railroad to be completed to Cleary and other towns and diggings that soon grew up in the area. Without a railroad, the Cleary mines were limited in their productivity by costs. The high

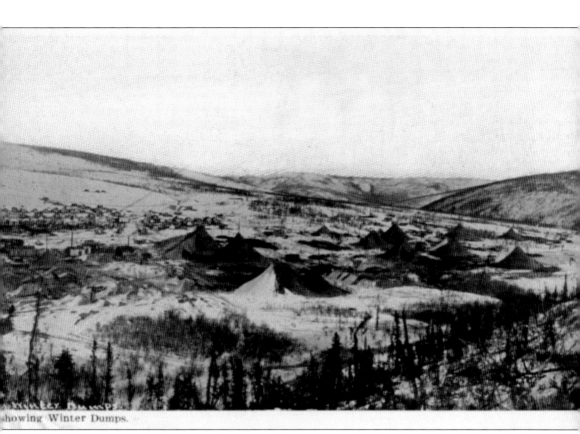

showing Winter Dumps.

cost of transport, at $10 per ton-mile, restricted mining to only the richest ground, but with the railroad's per-ton-mile cost of 53¢, Cleary mines produced huge profits. Today, the hillside that Cleary was built on is again forested, having recovered from the cutting of its timber for fuel. (Waugaman, 12-01_0077.)

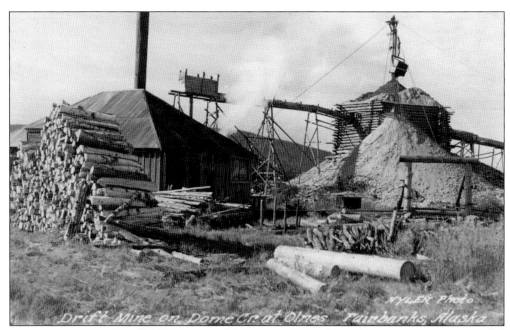

Drift Mine on Dome Cr at Olnes Fairbanks, Alaska NYLEN Photo

Heavy equipment driven by steam power was needed to mine, and a railroad was needed to bring the equipment from the ports. Above, at Dome Creek, near Olnes, wood is stacked in front of a boiler house. Steam powered the bucket that lifted the dirt from the bottom of the mine to the top of the pay dirt dump. Steam was also needed to thaw the frozen ground. (Waugaman, 12-02-26_0009.)

Most railroad books focus on the "big wigs," or executives, but it was the little guys who did the work. Robin C. "R.C." Sheedy (1884–1952), seen here at age 16, heard the call of the North in 1904 at the age of 20. He signed on the TMR as a "professional hunter" in mid-1904. The rest of the photographs in this chapter were taken by Sheedy during his Alaska adventures. (Nick Sheedy collection, No. 27.)

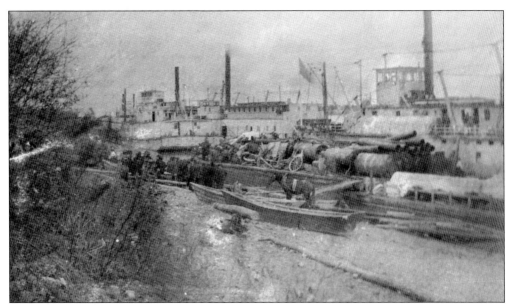

In 1904, R.C. Sheedy traveled over the WP&Y with railroad construction materials for the TMR. Here, at Fort Gibbon, he and the railroad materials on the stern-wheeler *J.P. Light* paused before the trip up the Tanana River to Chena. Various mining equipment, including large pipes and boilers, are on the barges. (Nick Sheedy collection, No. 07.)

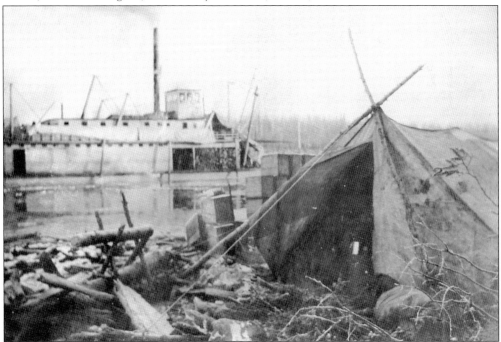

Winter waits for no man, steamboat, or railroad. Dropping water levels grounded the *J.P. Light* with too much cargo. Sheedy and the rail cargo were left to spend the winter about 60 miles short of Chena. Sheedy was provided with two bags of beans, other supplies, and instructions to survive with his hunting skills and guard the railroad property for the winter. (Nick Sheedy collection, No. 10.)

Sheedy set about building a cabin and hunting for his dinner. It is not known if he considered this a step up or down from his "overturned boat" berth on the deck of the riverboat. Seen here are some of the supplies he was charged with guarding. (Nick Sheedy collection, No. 13.)

With the canvas "door" open wide, Sheedy's cabin was better winter quarters than a tent. When he finally built a door for his cabin, he was proud enough to photograph it also. This cabin is not very different from a typical miner's cabin. Sheedy's film suffered during the two years he spent in Alaska before it was developed. (Nick Sheedy collection, No. 17.)

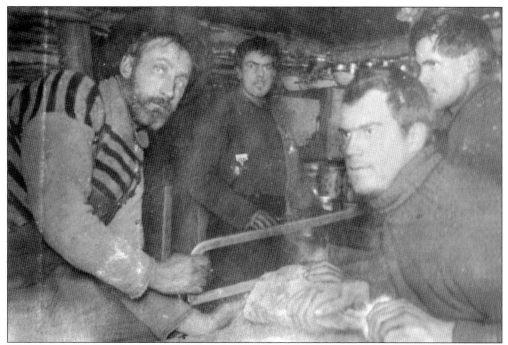

Sheedy must have been a successful hunter, as he is seen here with his friends sawing up a frozen moose leg inside his cabin. The men are identified as, from left to right, Ed, Jack, R.C. Sheedy, and Sam. This was typical fare and living conditions in the Fairbanks mining district for many years. (Nick Sheedy collection, No. 16.)

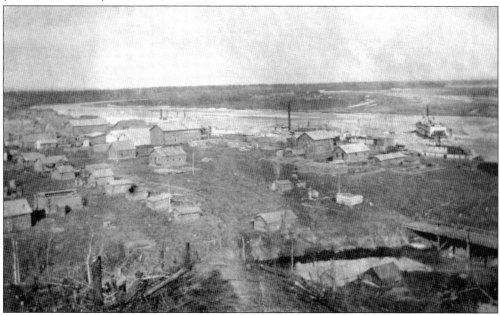

R.C. Sheedy made it to Chena by early 1905 from the railroad material cache. He captured this image of several riverboats frozen in the Tanana River in April 1905. Sheedy's unique camera position shows Chena from a different angle than other early images. There are about eight riverboats frozen in the river, including one mid-stream. (Nick Sheedy collection, No. 18.)

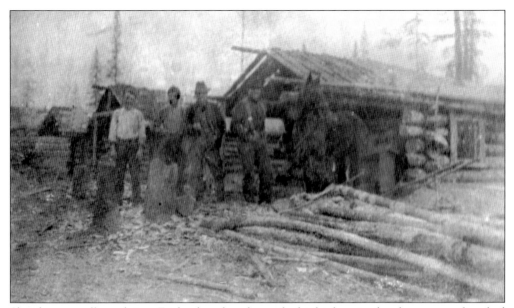

Sheedy eventually made it to Fairbanks, where he made this his hunting headquarters and worked for the TMR. There are logs for firewood and likely for new cabin construction as well, as bark peelings indicate cabin log preparations. These were typical dwellings for the average working man in Fairbanks around 1905. (Nick Sheedy collection, No. 19.)

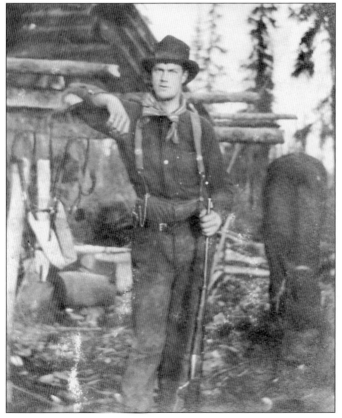

This timeless image of a proud R.C. Sheedy and his mule is a portrait of a successful frontier man. Hanging in the background are harnesses and fur stretchers. Sheedy trapped animals and also took up hauling mail via dog sled to Valdez in the winter. He left the area two years after he arrived. (Nick Sheedy collection, No. 20.)

Two

EARLY CONSTRUCTION OF THE TANANA MINES RAILWAY

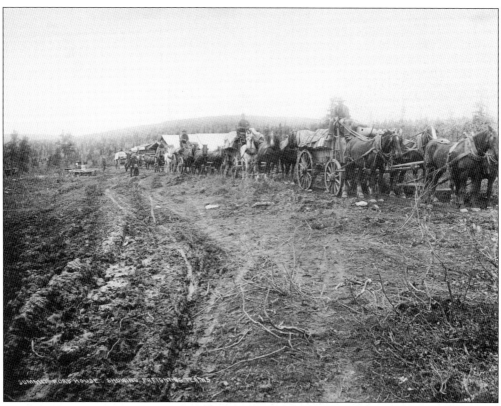

The need for some form of transport other than horse and wagon over muddy trails in thawing permafrost was known to all Klondikers, and soon became apparent to the miners in Fairbanks. The Tanana mines were far from riverboat transport and needed rail transport. The closest gold creeks were 20 miles away, and the richest diggings were twice that far from Chena or Fairbanks. (UAF, 1979-0041-00206.)

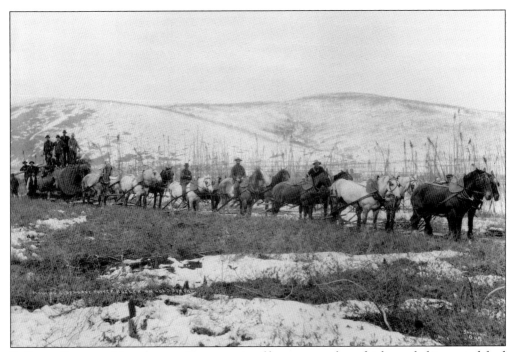

Rail travel's competition was massive amounts of horses or mules, which needed imported feed year round. Here, according to the original photograph caption, 14 horses and 14 men move "a 60 horse power boiler on Goldstream." (UAF, 1989-0166-00051.)

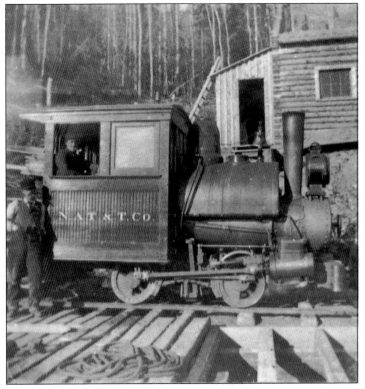

This coal-burning locomotive, an 8.5-ton 0-4-0T with 12-inch-by-7-inch cylinders, 24-inch wheels, a 36-inch gauge, and an extended smoke box was made as a stock item by the H.K. Porter Company on January 12, 1899, as builder's number 1972. On May 5, 1899, it was purchased by the North American Trading & Transportation Company (NAT&T) to become Engine No. 1 for their coal mine at Cliff Creek in Yukon Territory. (Dawson City Museum, 1997.298.8.)

H.K. Porter No. 1972 is seen here crossing a tributary of Cliff Creek on its way to the coal mine. Cliff Creek was a little tributary of the Yukon River, 59 miles downstream from the famous Dawson and Klondike gold discoveries. In order for this engine to join in the gold rush, it was taken apart by the Porter Company, boxed for export, and shipped on May 10, 1899, to the Yukon. (Dawson City Museum, 1997.298.17.)

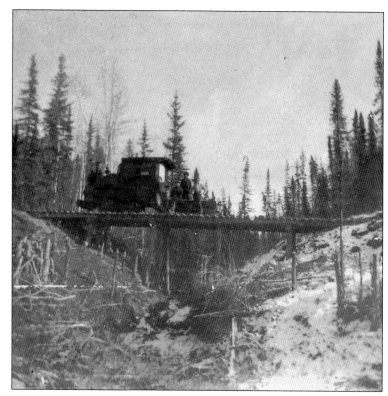

This photograph, perhaps an accidental one, captures the little Porter parked at the Cliff Creek coal terminus with the Yukon River in the background. Transportation was very limited in 1905, and shipping a locomotive via a river depended on the river being high and ice-free, so it was best to look around for something local. Falcon Joslin did just that, purchasing this engine for the TMR in 1905. (Dawson City Museum, 1997.298.15.)

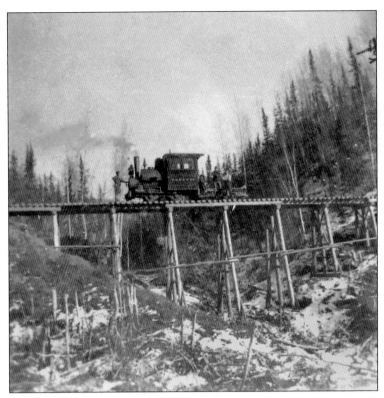

NAT&T No. 1, seen here when it was still in the Yukon, was soon to begin a new life in a new home—a good fate for such a cute little engine. (Dawson City Museum, 1997.298.4.)

Cliff Creek had a steep gradient, and the 1.75-mile track crossed the creek half a mile upstream from the Yukon. The Cliff Creek mines proved hard to mine and soon ran out of coal, so the engine was moved to the Coal Creek coal mines. But it did not stay there long, soon traveling to the gold diggings and becoming TMR's Engine No. 1. (Dawson City Museum, 1997.298.14.)

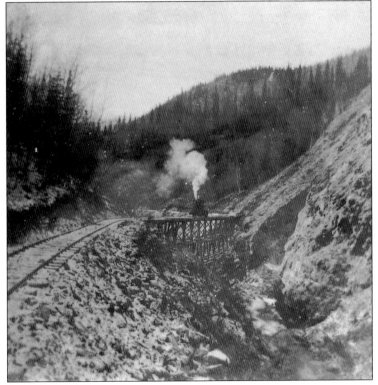

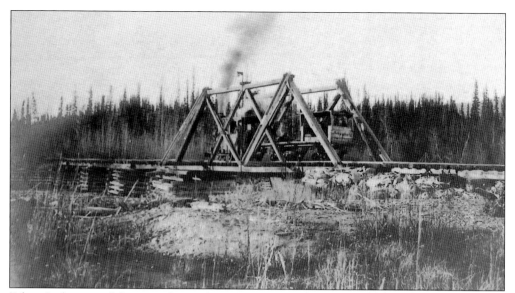

Falcon Joslin owned shares in the Coal Creek Coal Company, which likely made his purchase of this H.K. Porter locomotive for the TMR easier. This enabled Joslin to get a locomotive to the Fairbanks mining district faster than if he had ordered it from the contiguous United States. The shipping season was limited to the ice-free rivers of summer, making such deals the best way of progressing. (Dawson City Museum, 1999.12.1.19.)

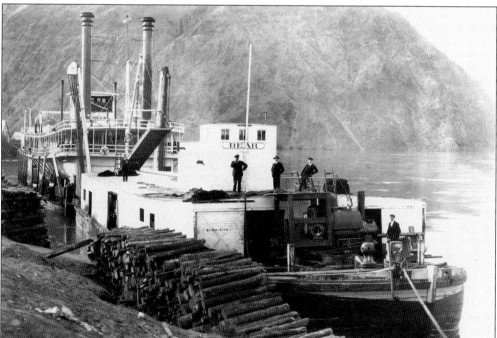

Along the way the way to Fairbanks in 1905, the Porter was photographed by C.L. Andrews riding on the barge *Bear* and pushed by the stern-wheeler *Louise*, tied up at Eagle, the international boundary on the Yukon. The engine's cab is beat up, and the roof has been replaced with tin. The headlight was removed and stuffed inside. Coal mining was tough on the engine. (Michael Nore collection.)

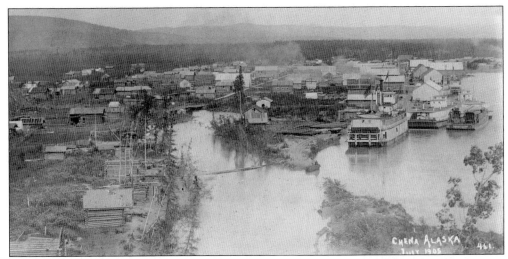

Engine No. 1 has been landed and is on Front Street, dating this photograph after July 5, 1905. The leaves are not fully out on the deciduous trees and shrubs, but should have been. Compare this image of Chena with the close-up below. (Waugaman, 10-Jun 2012_0009.)

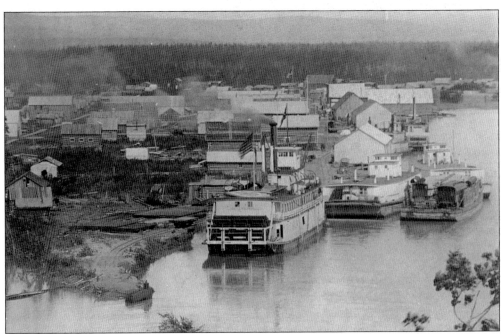

Looking closer at the image above, Engine No. 1 is pulling a small, four-wheel flat on the rail laid on the street. There is a pile of rail to the left of the last steamboat and between them is another four-wheel flatcar. A boiler is sunk in the junction of the creek and river. TMR's first passenger car and possibly a boxcar are on the barge to the right. (Waugaman, 10-Jun 2012_0009.)

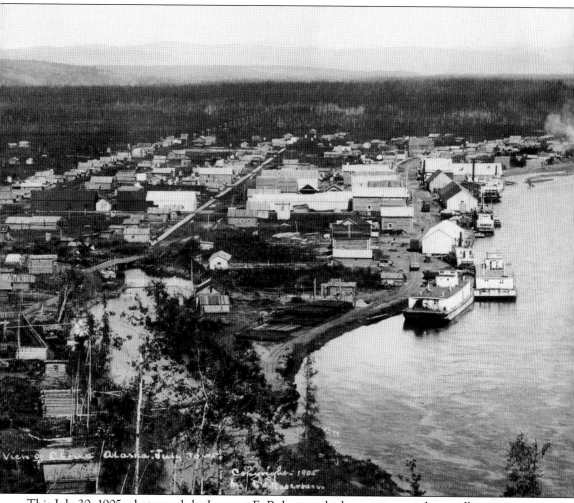

This July 30, 1905, photograph by Lorenzo E. Robertson looks upstream at the rapidly growing Tanana River port of Chena. Progress was made quickly after the arrival of Engine No. 1 on July 5. On shore, just downstream from the closest barge, are the growing stacks of rail for extending the TMR. From the rail stacks, tracks are laid in the street, where a flatcar and two boxcars can be seen. The rails to the gold fields ran north (up). (FTVRR, P No. 2, Chena, 1905.)

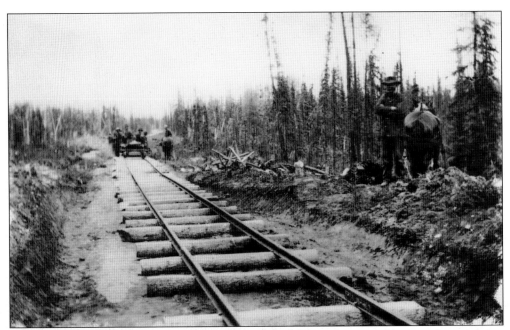

A work crew of eight, with two mules and a four-wheel car are laying rails on nearly round ties. Joslin reported that by November 4, 1904, the grading was completed between Fairbanks and Chena. The rough spruce ties, wearing bark, are spaced very far apart. Rails first arrived at Chena in 1905. (Paul Solka, Deely collection, 0006-cr.)

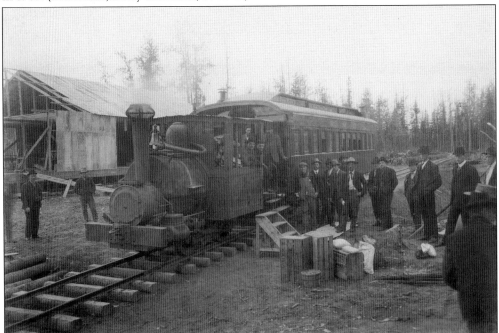

This image must be from very early in the history of the TMR, in late July or early August 1905. Without a tender or a flatcar to carry fuel, little Engine No. 1 has pulled a passenger car to Fairbanks. In the left background, TMR's first freight shed is under construction. The passenger car is marked T.M. Ry No. 100. (Michael Nore collection.)

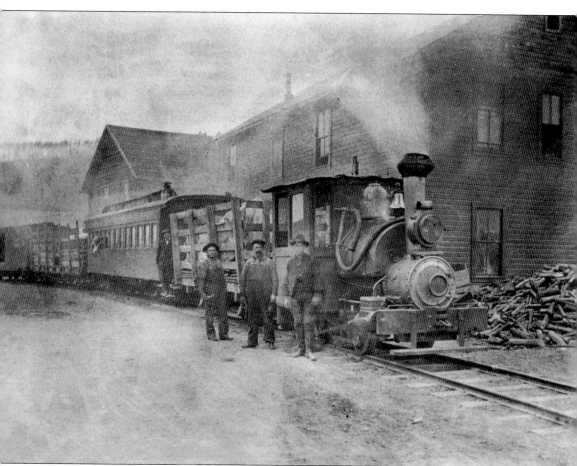

Engine No. 1 was put to work immediately after its arrival at Chena. Here, the little engine gets ready to leave Chena for the gold fields or for Fairbanks. The large hose wrapped around the saddle tank is for sucking water from nearby ponds and creeks for boiler water. The woodpile on the other side of the engine is likely fuel for the engine. Originally designed as a coal burner, No. 1 soon got used to burning wood in Fairbanks. The flatcar with stake sides appears to be holding plenty of wood for the trip. (Waugaman collection.)

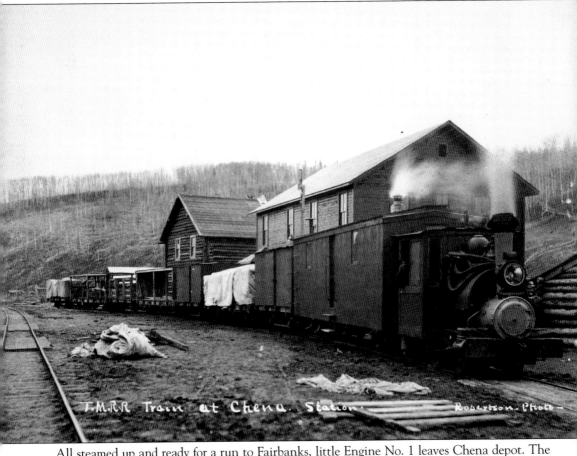

T.M.R.R. Train at Chena. Station — Robertson Photo

All steamed up and ready for a run to Fairbanks, little Engine No. 1 leaves Chena depot. The H.K. Porter, weighing just 8.5 tons, appears to be pulling a tremendous load—eight cars. The rails to Fairbanks have almost no grade, which makes it a possible load. The scheduled passenger time to Fairbanks was 40 minutes, with the trains going about 12 miles per hour and freights likely slower. The first boxcar has two windows, a narrow doorway on the side, and a smoking chimney. (Waugaman, 12-02-26_0001a.)

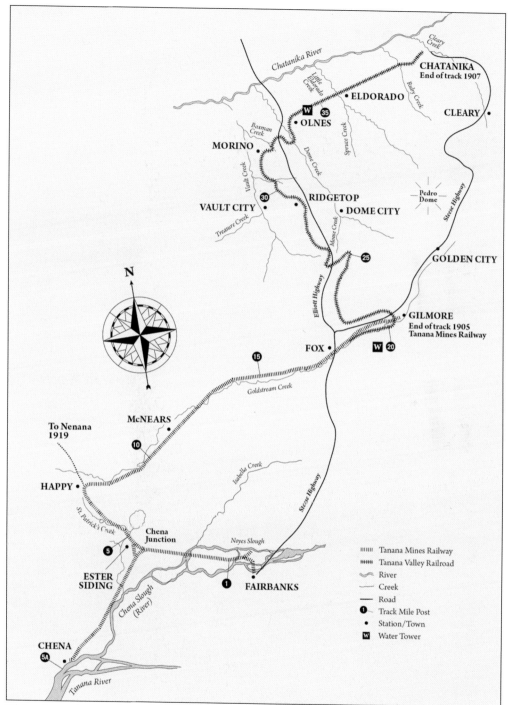

This schematic map shows the TMR as it existed in 1905 and the TVRR as it was built in 1907. There was water for the locomotives in Gilmore and Olnes, as indicated on the map. A few modern roads were sketched in as well. (© 2012 Osborne.)

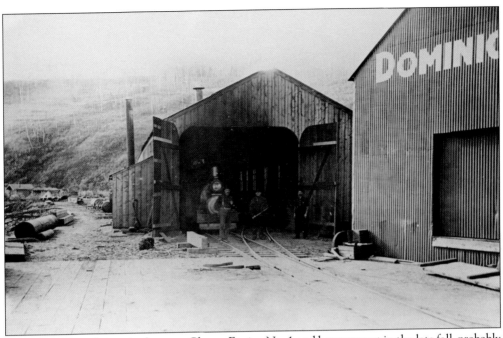

Tucked snugly in the engine house at Chena, Engine No. 1 and her crew rest in the late fall, probably in 1907. To the left of the engine house is the old right-of-way, which was used to unload the rails from the paddle-wheel boats. The tracks to that landing have been removed. The Dominion Commercial Company warehouse is on the right. (Joslin collection, UAF-1979-0041-0172.)

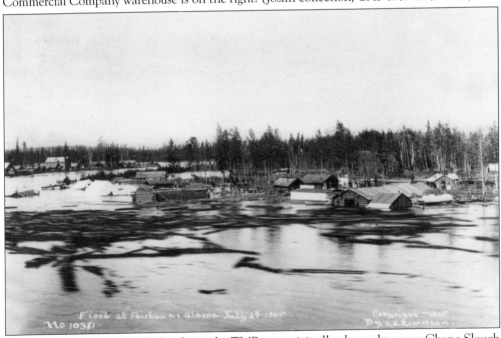

According to Judge James Wickersham, the TMR was originally planned to cross Chena Slough and end in "down town Fairbanks," and "ruin the finest street in Fairbanks." This flood, on July 6, 1905, washed out the new railway bridge from Garden Island to Fairbanks. Because of this, the TMR ended north of Fairbanks and never crossed the slough. (Waugaman, 12-02-26_0049.)

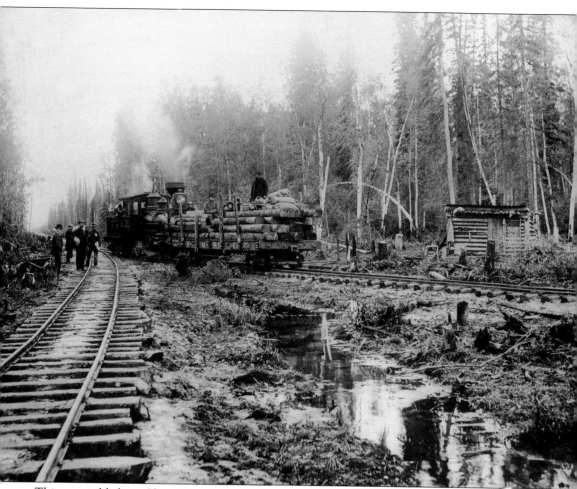

This wye is likely at Chena Junction, which now holds the fields for the University of Alaska-Fairbanks Experimental Farm. The engine is pushing a load of railroad ties that were flat on only two sides. That type of track construction material dates this image to early 1905. TMR Engine No. 50 is linked to Klondike Mines Railway (KMR) Flat No. 51. KMR ordered Flats No. 51, No. 53, and No. 61 to be built by the White Pass and Yukon Railroad. However, due to finances, KMR never completed the purchase. TMR then purchased them, but did not repaint the markings. On the left edge of the photograph, off the tracks, is a velocipede. (UAF, 2002-0134-00006.)

THE TANANA MINE RAILWAY.
FAIRBANKS, ALASKA.

The rails from Chena were planned to go directly to the gold creeks, but the town of Fairbanks quickly grew into significance and needed rails first. Fairbanks had shorter and better trails to the various gold-bearing locations. Before the railroad got started, Fairbanks grew larger than Chena. Here, Engine No. 1 is paused, awaiting the photographer. The engine is in better condition than it was on the barge *Bear*, but it still has its tin roof. Also seen are the passenger car T.M. Ry No. 100 and the short boxcar T.M. Ry No. 203, at the Chena Junction wye between Chena and Fairbanks Stations. The TMR also had turning wyes at Chena and Fairbanks. Four wheelbarrows for roadbed construction are between the tracks. (UAF, 1979-0041-0045.)

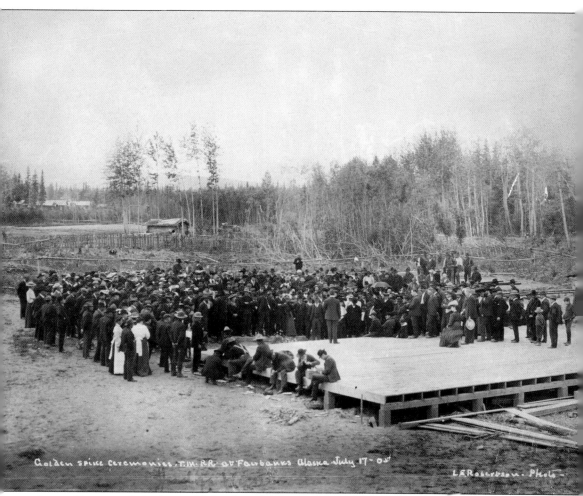

Golden Spike Ceremonies T.M.R.R. at Fairbanks Alaska July 17-05

L.E.Robertson. Photo.

A crowd listens to Judge James Wickersham delivering an address at the Golden Spike ceremonies for the TMRR in Fairbanks on July 17, 1905, celebrating the completion of the tracks from Chena to Garden Island. The judge is in the center on the platform with his back to the camera. At the ceremonies, the judge was presented with the "first spike" of the TMR, which was driven at Chena. His speech, which was later published, was not very dedicatory. Instead, it was a blast at the US government, and not very flattering towards the Philippines, whom the judge thought did not deserve the preferential treatment given it. He thought Alaska deserved and should receive preferential treatment. The judge and some listeners are standing on the first floor of what became the Fairbanks depot of the TMR. Note the rails to the upper right of the platform. (ASL PCA, 277-011-132.)

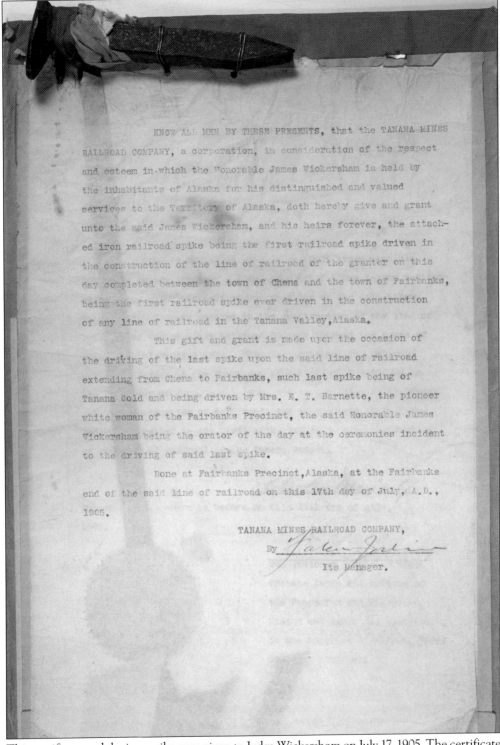

KNOW ALL MEN BY THESE PRESENTS, that the TANANA MINES RAILROAD COMPANY, a corporation, in consideration of the respect and esteem in which the Honorable James Wickersham is held by the inhabitants of Alaska for his distinguished and valued services to the Territory of Alaska, doth hereby give and grant unto the said James Wickersham, and his heirs forever, the attached iron railroad spike being the first railroad spike driven in the construction of the line of railroad of the granter on this day completed between the town of Chena and the town of Fairbanks, being the first railroad spike ever driven in the construction of any line of railroad in the Tanana Valley, Alaska.

This gift and grant is made upon the occasion of the driving of the last spike upon the said line of railroad extending from Chena to Fairbanks, such last spike being of Tanana Gold and being driven by Mrs. E. T. Barnette, the pioneer white woman of the Fairbanks Precinct, the said Honorable James Wickersham being the orator of the day at the ceremonies incident to the driving of said last spike.

Done at Fairbanks Precinct, Alaska, at the Fairbanks end of the said line of railroad on this 17th day of July, A.D., 1905.

TANANA MINES RAILROAD COMPANY,

By *Falen Jordi*

Its Manager.

This certificate and the iron spike were given to Judge Wickersham on July 17, 1905. The certificate attests that this is indeed given to the judge and is the first spike of the TMR. (ASL ms107-46-8.)

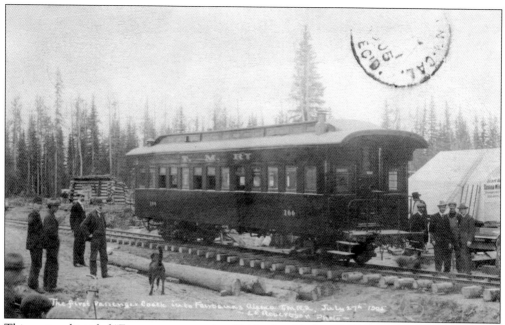

This postcard is titled "First passenger car into Fairbanks, Alaska, T.M.R.R., July 27 1905," indicating that there were no passenger cars available from the landing of Engine No. 1 until July 27. The car is lettered T.M. Ry No. 100, and the tent behind the car was the ticket office—TMR was a truly primitive operation at the time. (Waugaman, 12-02-26_0067.)

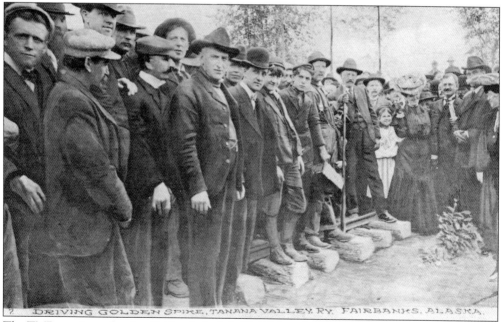

The TMR was "complete" to Fairbanks by July 17, 1905, and the customary golden spike ceremony was held. The tall gentleman looking into the camera in the center-left appears to be Martin Harrais. On the right, holding up the golden spike, is Isabell Barnette, who was selected to drive the spike. Judge Wickersham is immediately to the right of her. (Waugaman, 12-02-26_0008.)

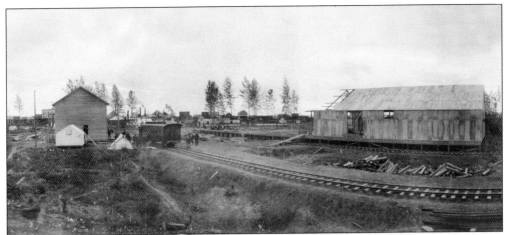

This photograph shows the original TMR station and terminus on Garden Island in Fairbanks. The building on the left, behind the tents and the velocipede, is the new station building under construction; across the tracks, the TMR warehouse was under construction. Beyond the trees and across the Chena Slough, behind the riverboats, is Fairbanks. Passenger car No. 100, pulled by Engine No. 1, is parked by the station. (UAF, Robertson 15.)

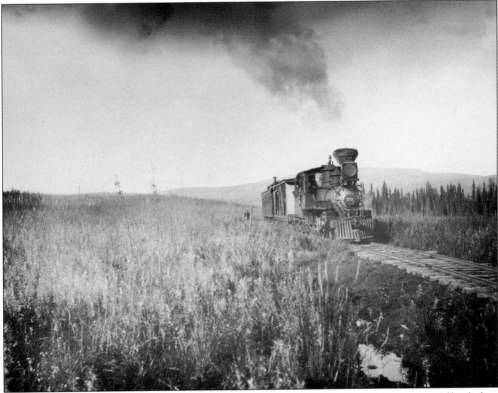

Engine No. 50 slowly pulls a typical mixed freight and passenger car up Goldstream Valley below Fox. The track condition was generally very poor, which limited speeds. Goldstream Valley is permafrost ground, which soon began melting and dipping the track once it was cleared for the right-of-way. Here, the forest has been burned and fireweed is flourishing. Ester Dome is in the background behind the engine. (Joslin collection, UAF 1979-0041-0051.)

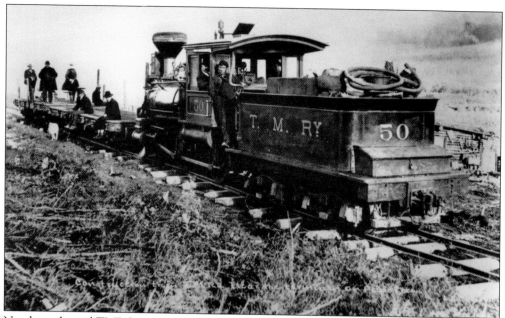

Northeast-bound TMR locomotive No. 50 pushes a construction train, with a crew of 10 and a dog, near the terminus of Pedro Creek (Gilmore), at mile 20 in the 1905 construction. The waters of Pedro and Gilmore Creeks join to form Goldstream Creek. Later, in 1907, the rail would loop here and back to the southwest to climb over the pass to the Chatanika Valley. (Bruce Halderman, Deely collection, 0010.)

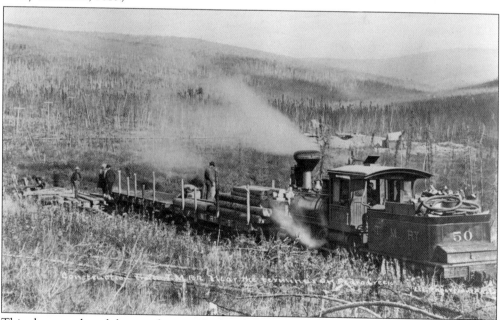

This photograph and the one above are both titled "Construction train TM RR near the terminus on Pedro Creek, L.E. Robertson Photograph," but they are different. In the above image, all the ties are gone from the flatcar, and Gilmore Creek comes in from the right to join Pedro Creek just above the engine. It was about here that Gilmore station was built. Both flats are marked for the Klondike Mines Railway. (Waugaman, Deely collection, 0037a.)

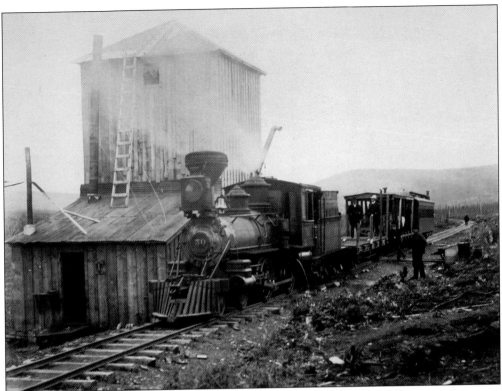

The first large engine to arrive on the TMR was No. 50. This Baldwin 4-4-0 was a mainstay on the lightly and poorly laid tracks of the early years. It is seen here stopped at a water tank between Fox and Gilmore around milepost 19.2. (UAF, 1979-0041-00055.)

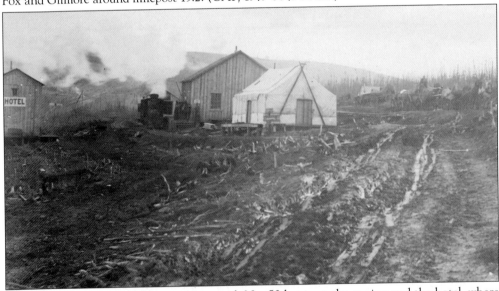

This photograph shows Gilmore station, with No. 50 between the station and the hotel, where the tracks ended in 1905. Also seen is the rough "Road at Gilmore" that made the railroad the preferred means of transport. Gilmore station was a dead-end short spur on 1916 maps. Gilmore was the far terminus from 1905 to 1907. (UAF, 1979-0041000056.)

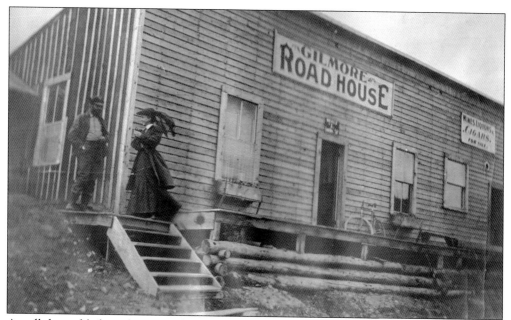

A well-dressed lady with a parasol waits at the Gilmore Roadhouse in preparation for a ride on the TVRR in 1907. The roadhouse sign boasts meals for $1, and wine, liquor, and cigars for sale. Note the bicycle on the deck. (Waugaman, 12-02-26_0028-c.)

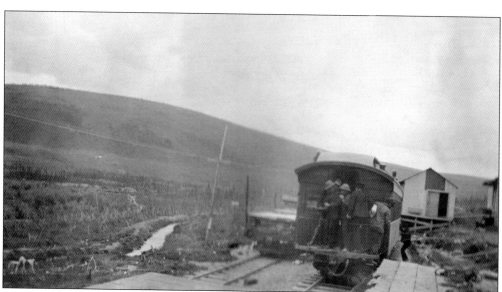

Also at Gilmore station, this photograph looks back toward Fairbanks. This may be TMR-TVRR passenger car No. 100. The brakeman releases the brakes as the last passenger climbs in the forward end of the passenger car. (Waugaman, 12-02-26_0026-c.)

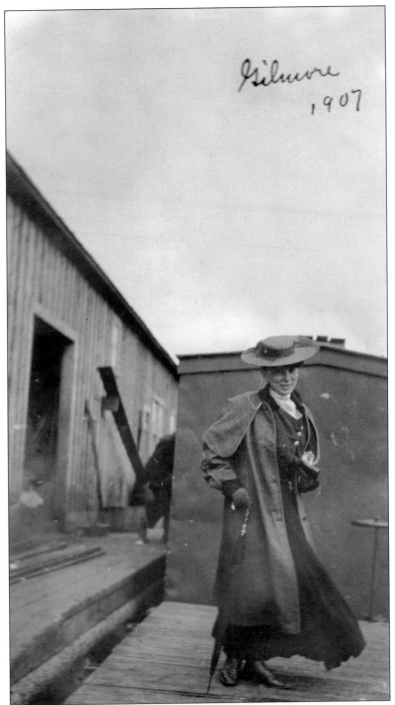

Here, the lady from the previous page, in the same outfit, stands on a flatcar. The boxcar behind her appears not to have any fasteners on the end, and shows wrinkles, as if the entire end is one piece of sheet metal. There was some damage to the original image, but not where the wrinkles appear. The boxcar could be one of TVRR's insulated "hot cars," which were used to keep baggage and freight from freezing in the winter. (Waugaman, 12-02-26_0029-c.)

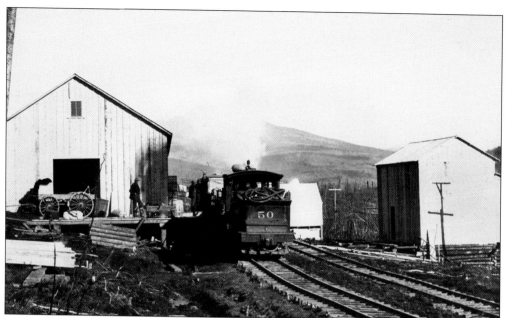

As noted on the image below, the end of the rail until 1907 was here at Gilmore station, at the head of Goldstream Creek 20.5 rail miles from Fairbanks. Note the undulating rail bed on the left, which was completed just before the photograph above was taken, in October 1905. This was as close as the tracks got to Golden City, the site of Felix Pedro's July 1902 discovery of gold, three miles farther up Pedro Creek. In the image above, note the large hose on the tender; the TMR pulled water from creeks and ponds frequently in 1905. The TMR was unique in that it apparently did not use telegraphs for dispatching, using telephone communications instead. Pedro Dome is in the far distance. Later, when the tracks were extended to Chatanika, the loop was set up to the right of this image and the travel direction was then reversed so that trains went over the pass from right to left. (Above, Joslin collection, UAF 1979-0041-0047; below, Joslin collection, UAF 1979-0041-00041.)

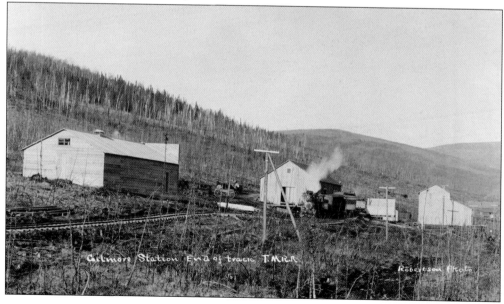

Gilmore Station End of track TMRR. Robertson Photo

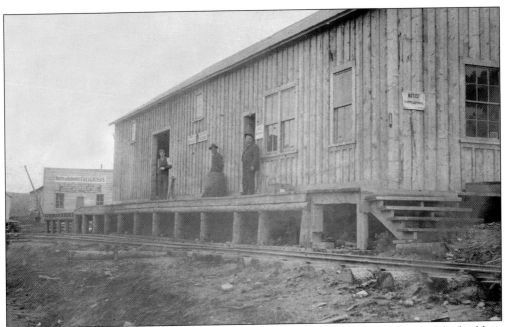

Falcon Joslin labeled this image "Gilmore Station." The notice on the close end of the building notes that some service is "25 Cents Additional," the first door has a lucky horseshoe over it, and midway down the building is a sign ending with "Drug Store." The last gentleman wears sleeve protectors over his white shirt, indicating that he is a clerk. In the distance, another building sports two signs: "Boyd & Hornby Freighters" and "Chena Lumber & Light Co's. Yard, Rough and Dressed Lumber, Sawmill. Water and Iowa St, Chena." Fires at Gilmore station in 1907 and 1909 burned these buildings. (UAF, 1979-0041-00057.)

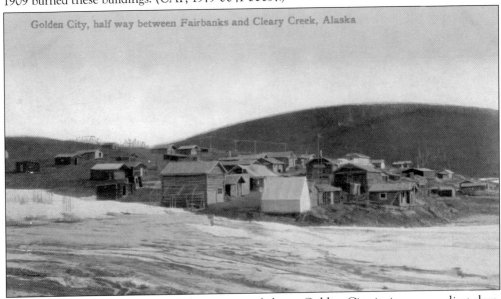

This early hand-color-tinted real-photo postcard shows Golden City in its very earliest days, before mining was mechanized. In the foreground is a large single sheet of ice formed from stream overflow during the past winter, another hazard of the North. Pedro Dome is in the distance, with Cleary City on the other side of the dome. (Waugaman, 12-01_0066-B&W.)

Three

EXTENSION AND THE DREAMS OF JOSLIN

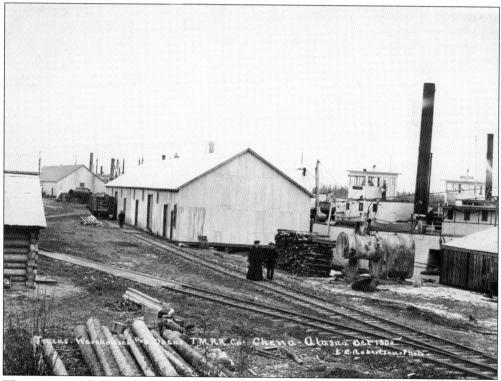

This image is titled "Tracks, Warehouse and Dock TMRR Co., Chena, Alaska, October 1905." Steamers *Margaret* and *Delta* are landing freight. The need for transport other than sled or packsaddle is apparent. The locomotive-type boiler was a miner's favorite tool to thaw frozen ground and run steam-powered hoists. Heavy equipment was an economic mainstay of the TMR. Soon, these riverboats would freeze in for the winter. (Joslin collection, UAF 1979-0041-0048.)

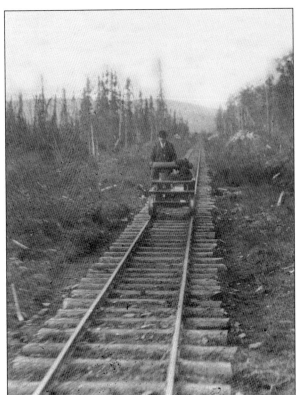

A well-dressed gentleman, not a common laborer, rides this small gas car. The rough-cut ties are barely debarked. The locally cut spruce wood quickly rotted, contributing to the maintenance problems of the railroad. These ties, with insufficient ballast for a long-life track, were laid directly on the forest moss to avoid melting the permafrost. (Joslin collection, UAF 1979-0041-0086.)

Below, near Fox Station, behind the horses on the left, the rails sag from melting permafrost. The ties are only sided on two surfaces, an improvement over the un-cut ties in other places on the roadway. The Fox Roadhouse, across the tracks, still stands today, enclosed inside the Silver Gulch Brewery. The many teams and wagons seen here are likely waiting for the train. (Joslin collection, UAF 1979-0041-0052.)

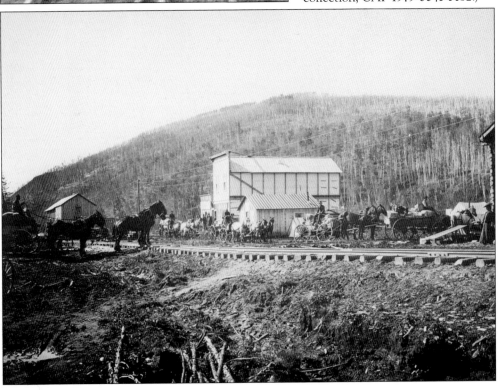

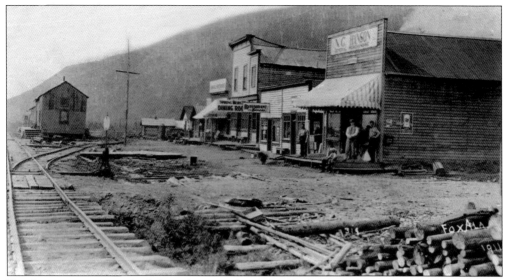

Fox Station is seen on the left in this view from 1911, looking southwest. The buildings on the right are the N.C. Hanson general merchandise store, a restaurant and bakery, and a hotel with a sign reading "Spring Beds 50¢ and Dining Room." The station shed has tracks on both sides; the main line is on the left, and a stub switch controlled the intersection. This was a common station configuration for the TMR and TVRR. (Olga Steger, Deely collection, 0002a.)

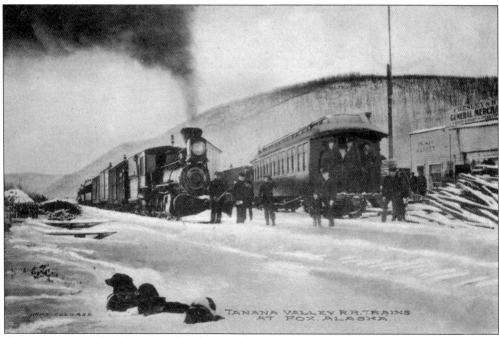

Two trains meet in Fox in winter. This photograph may have been in the early days, when the railroad operated two trains per day to the end of the line, summer and winter. The sled dogs in the foreground seem unconcerned with the competition of the iron horses. (Waugaman, 12-01_0067.)

No. 247 COMMON STOCK TRUST CERTIFICATE 2 Shares

TANANA VALLEY RAILROAD COMPANY

This is to Certify, That, as hereinafter provided, H.B. Petty will be entitled to receive a certificate or certificates for Two # ...

(body text of stock certificate)

FALCON JOSLIN,
PETER DUDLEY, } Voting Trustees.
BENJAMIN L. ALLEN. }
BY THEIR AGENT,
KNICKERBOCKER TRUST COMPANY,

In 1907, the Tanana Mines Railway was reorganized into the Tanana Valley Railroad (TVRR) and issued new stock. This low-cost, unembellished certificate is for two shares, with a par value of $100. It was purchased by H.B. Petty on July 1, 1908. (FTVRR collection.)

The reorganized railroad also issued bonds, which together with the new stock enabled the TVRR to extend the track to Chatanika. This bond, issued on January 1, 1907, is for $1,000, with 6-percent annual interest. Before being voided with punched holes, it appears that interest was paid up to about 1915. Typical of the time, the interest was payable in gold. (Waugaman, TVRR Bond, Page 1.)

This preferred stock certificate for five shares (above and below) was purchased by G.A.S. Northcote on April 27, 1912, with a par value of $100. Preferred stock paid dividends before common-stock dividends were paid. (FTVRR archives, TVRR Stock Certificate, 0003.)

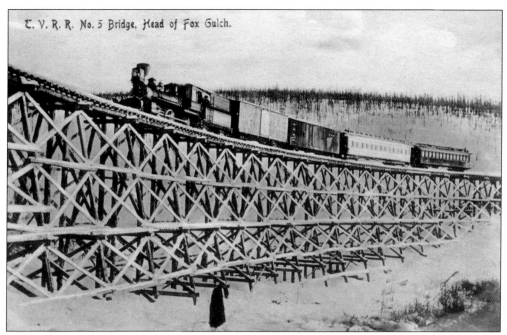

The TVRR, in its push over the pass to the Chatanika River Valley, crossed the head of Fox Creek Gulch on this impressive trestle. This winter scene has Engine No. 51 posed for the photographer. The TVRR ran two trains per day from Fairbanks to Chatanika throughout the winter and summer in its early days. (Waugaman, 12-01_0061.)

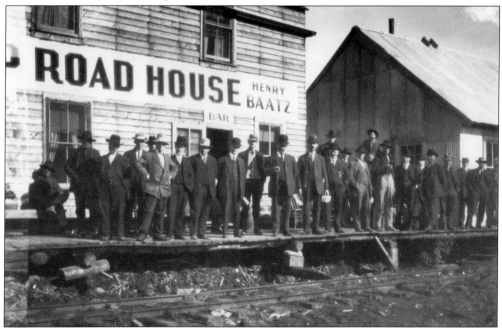

Next to Gilmore station was the Loop Roadhouse, which took its name from the large loop where the TVRR rerouted the tracks to double back and climb over into the Chatanika Valley. The deck, even with its questionable supports, was able to hold this well-dressed group awaiting the train. To the right is the station itself. (Waugaman, 12-01_0104.)

The Loop Roadhouse burned at least once, and maybe twice. On April 15, 1914, it burned, charring the nearby freight shed, as seen in later photographs of the station. Nicholas Deely has located the Loop Roadhouse at mile 21.4 of the TVRR, just north of the curved, 403-foot Trestle No. 1. (Waugaman collection.)

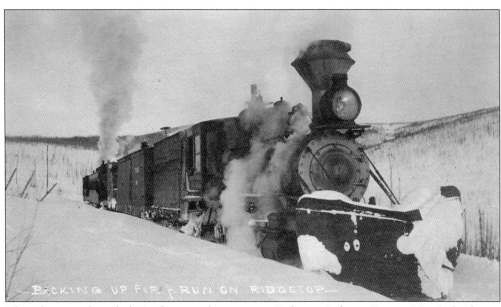

This photograph, titled "Backing up for a run on Ridgetop," shows Engine No. 52 leading a doubleheader, demonstrating that even the power of two locomotives was not enough to get through. Ridge Top, a very small depot for freight and passengers, was not very much lower in elevation that the Fox Creek pass. (Waugaman, 12-01-0011.)

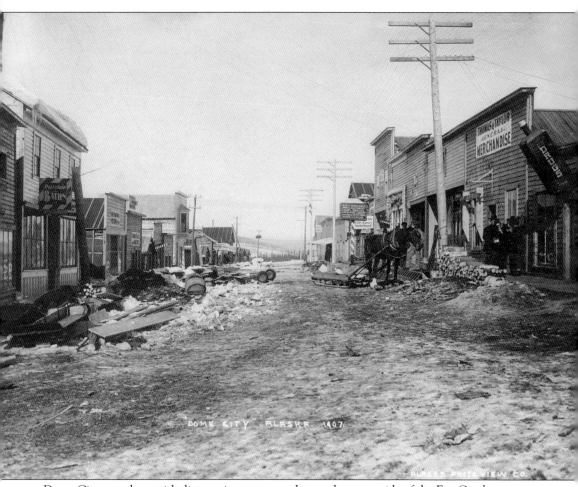

Dome City, seen here with dirty spring snow, on the northeastern side of the Fox Creek pass, was a small but thriving town. It had the advantage of a short trail from Fox station when the TMR stopped short during the initial construction in 1905. Dome City boasted a first-class hotel, two banks, two restaurants, a drug store, a hospital, a book and stationery store, two dance halls, six saloons, six general stores, three barbershops, two bathhouses, and a laundry, all of which were typical for most gold towns outside Fairbanks. With the extension, Dome City was served by rail from the Ridge Top station and from Olnes. (UAF, 2002-0134.)

The owners of Dome City Bank, Belinda Carbonneau (3) and her sister Margaret Mulrooney (4), inspect large gold nuggets in front of the bank in 1907. Carbonneau and Mulroony serviced Dome City and its population of 850. Jack Tobin (1) was a layman—a mine lessee, who worked the mine for a share of the take, like a share cropper—of Claim No. 1, above Discovery, in Dome Creek. Miller Thosteseu (2) owned the mine. (Waugaman, 12-02-26_0004.)

Olnes (below), in the Chatanika River Valley, was the second station stop after Ridge Top. There was a siding there to support mining on the Chatanika River and in Dome Creek. This photograph, with buildings tipping and broken windows, was taken by the Alaska Road Commission after Olnes's better times had passed. Competition from government-built roads doomed the railroad. (UAF, 2003-63-47.)

In order to support industrial-scale mining like this, at the Eldorado Mining Company, cheap rail transport was needed to move the heavy equipment, supplies, and fuel. (Waugaman, 12-02-26_0012.)

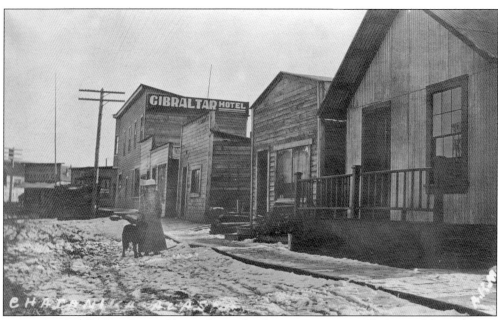

A young girl walks her dog in Chatanika in the dirty spring snow. All the TVRR towns and stations had telephone service, and several, including Chatanika, even had an electric power utility. Snow was removed from boardwalks, but the street snow was left to melt in the spring. Chatanika's Gibraltar Hotel stood tall above its neighbors. (Waugaman, 12-01_102.)

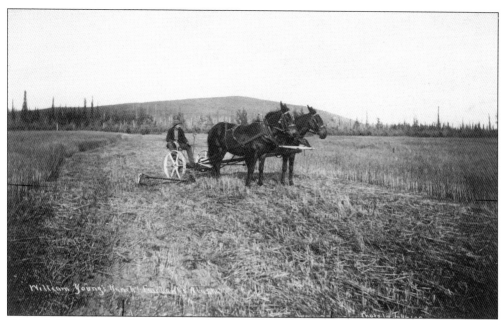

Falcon Joslin's photograph collection features many images like this one, of William Young's ranch. Joslin was a huge promoter of his railroad and the commercial prospects of the Tanana Valley, all in an effort to increase his railroad's revenues. He collected many photographs of the harvested crops of various farms and the fertile lands, which he shared with congressional committees and anybody who would listen. (UAF, 1979-0041-00030.)

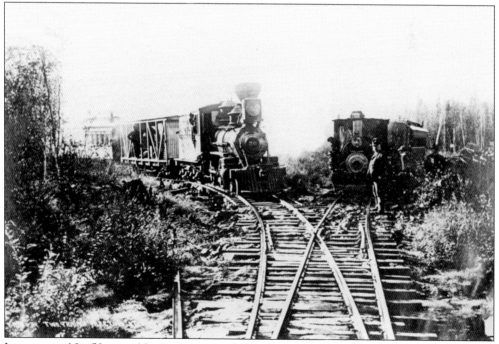

Locomotive No. 50 meets No. 1 at a wye, probably the one at Chena Junction. Little Engine No. 1 was stressed to perform as a major hauler until Engine No. 51 and Engine No. 52 finally arrived on the TMR. (UAF, 1971-0080-00017.)

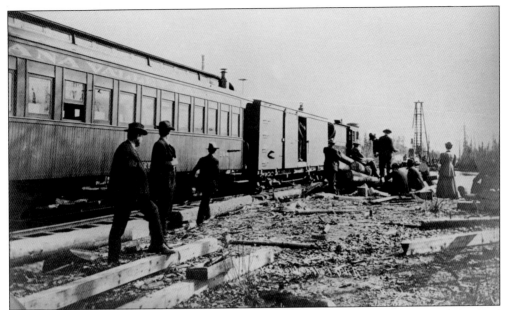

It appears that locomotive No. 50 is pulling its normal boxcar as a baggage car replacement, and passenger car No. 204 is waiting for some bridge repairs. The pile driver can be seen in the distance. The 10 ex-passengers, now volunteer supervisors, are watching intently. Judging by the width of the crossing, this appears to be Noyes Slough, on the main line to Fairbanks. (UAF, 1971-0080-00022.)

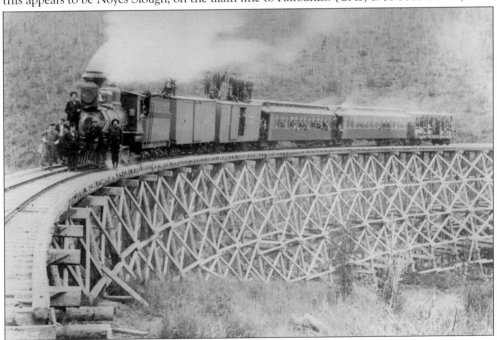

The TVRR frequently held excursions. This train has stopped on Trestle No. 5 at the head of Fox Creek before going to Chatanika. Locomotive No. 52 is pulling a typical consist, two boxcars as baggage cars, two passenger cars, and a flatcar made into an excursion flatcar. There are 19 people in front of the engine and on top, and many more inside. (Waugaman collection, Deely collection, 0033a.)

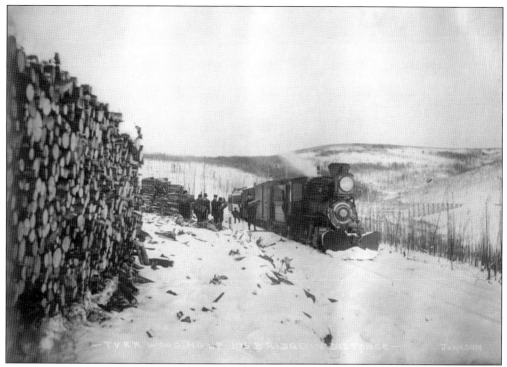

Engine No. 52, pulling two heated boxcars as baggage cars and two coaches, stops at Scrafford to "wood up" near the summit, on the way to Ridge Top. The longest trestle, the 502-foot Trestle No. 5, is in the right background. (Waugaman, 12-02-26_0034.)

The TVRR was hoping for the hard-rock mining boom that followed other placer gold rushes. Here, in 1911, the TVRR loads sacked antinomy ore from the "New Boy" mine at Eldorado station. Boxcar 112 is loaded with ore sacks, car 102 is a "baggage" boxcar, with its telltale stovepipe, and car 106 follows it. Another heated box brings up the rear. (Waugaman, 12-01_0031.)

This photograph, titled "Henry Koch, Jimmy Barrack, Chatinika [sic] Alaska 1915," shows men and dogs waiting for the train in Chatanika. The tracks lack any rock ballast, which was typical for the TVRR. The pole-line leans a bit, which was also typical for poles set in permafrost. (Waugaman, 12-01_0040.)

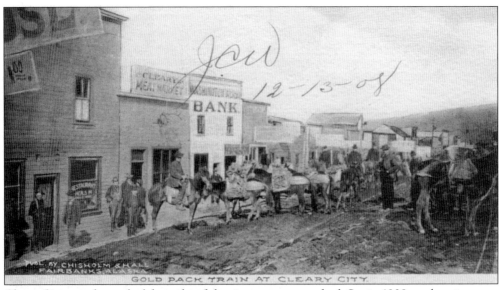

Cleary City was the goal of the railroad, but it was never reached. So, in 1908, pack trains were used to move gold. However, since there is no snow in this image and the people are dressed for warm weather, the date "12-13-08" is unlikely. The Cleary Meat Market is next to the Cleary branch of the Washington Alaska Bank, which failed in 1911. (Waugaman, 12-01_0049-c.)

Even though the gold creek towns were off the beaten track, the TVRR terminus town of Chatanika was expecting entertainment on July 15, 1914, by the Royal Players. Above, the players walk past a "Restaurant & Bakery, Oyster and Chop House," the Model Cafe, and the Pioneer Hotel. (Waugaman, 12-01_0058.)

The first winter's snows land on Chatanika, highlighting a lone boxcar on the TVRR. The boxcar is next to the combined station and freight platform. (Waugaman, 12-02-26_0021-c.)

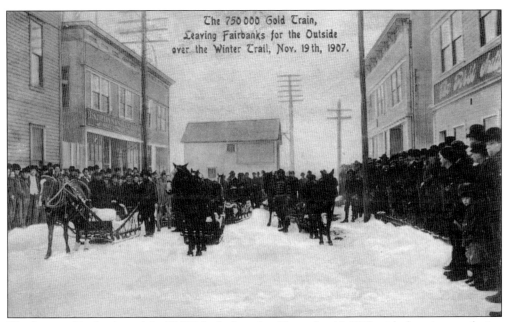

The futures of Fairbanks and the TVRR looked good on November 19, 1908, with the mines producing well. Joslin dreamed of a rail connection to the coast. Lacking a rail connection, horsepower was used to pull this ton of gold bars. The route was over the Valdez Trail to the US Mint in San Francisco. E.T. Barnette's Fairbanks Banking Company is on the left. (Waugaman, 12-01_0060.)

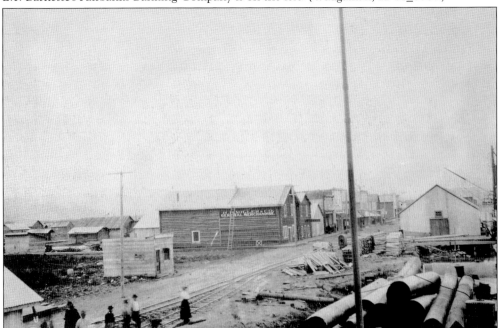

Seen here is busy Front Street in Chena City, with the TVRR tracks for car storage and switching. On the left is R.H. Miller & Co. General Merchandise, with people on the boardwalk and other businesses in the distance. On the right are a large-diameter hydraulic mining pipe and a boiler. Beyond the boiler is the TVRR warehouse and dock, with the Chena engine house in the lower left corner. (UAF, 1989-0166-00941.)

Four

EQUIPMENT AND STATIONS OF THE TMR AND TVRR

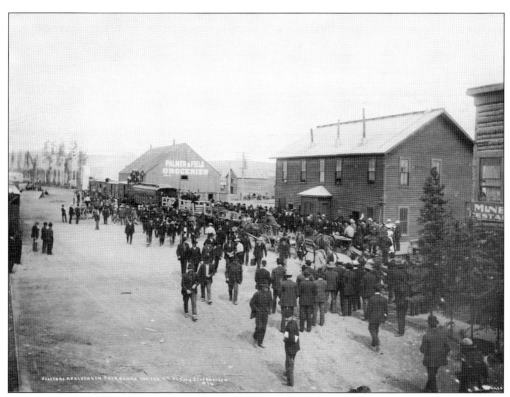

This 1908 Albert Johnson photograph, titled "Visitors Arriving in Fairbanks for the 4th of July Celebration" shows old North Turner Street in Garden Island. On the right are the Miner's Home, a hotel and restaurant; the TVRR depot (no sign); and the Palmer and Field Groceries warehouse. The train backed into the station consists of maybe Engine No. 51, three boxcars with roof passengers, one passenger car, and two flatcars, with packing boxes for benches. (UAF, 1977-0089-00023.)

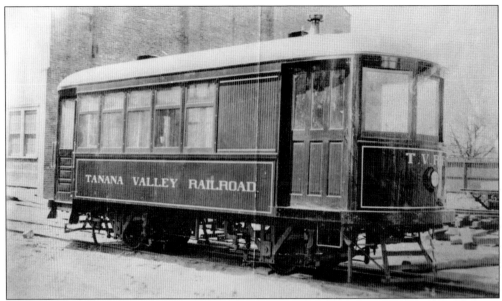

The TVRR operated this storage battery powered Federal electric car from Fairbanks to Fox. It was also used to commute from Fairbanks to Chena and the other stations short of the climb over Fox Creek Pass. Since bricks were not used in any early Fairbanks buildings, this photograph was probably taken in the lower 48 states by the builder. (Waugaman, 12-01_0009.)

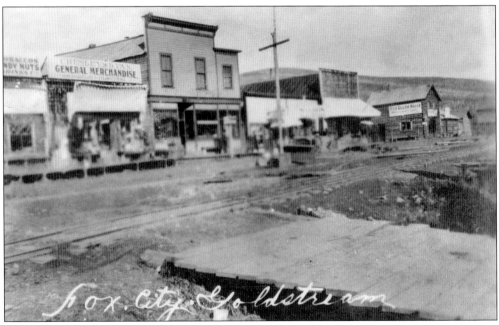

Fox is about eight miles from Fairbanks on the map, but 18 miles by track. It developed into a small town, serving as a railroad passenger and freight distribution point supplying the very rich mines nearby in Goldstream Creek. Store signs advertise, from left to right, "Tobaccos, Candy, Nuts, Drinks, etc.," "Chesley & Ryan, General Merchandise, Miners Supplies & Steam Fitting," and "Fox Gulch House, Wines, Liquors, Cigars." (Waugaman, 12-01_0097.)

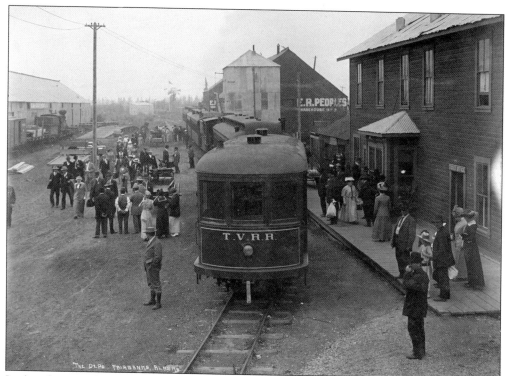

In this photograph, titled "The Depo Fairbanks, Alaska," a crowd has unloaded from a passenger train at the rear. They are walking towards the battery electric car that was used for local runs. In the back left, a freight train possibly pulled by Engine No. 50 is next to the long TVRR freight shed and car-loading ramp. The square tower building to the right of the train is the water tank. (UAF, 1968-0069-02874.)

While these fine gentlemen appear to be out for a Sunday drive, they are likely serious inspectors. In 1912, the Presidential Alaska Railroad Commission inspected all railroads and routes from tidewater to interior Alaska. The commission members are, from left to right, Maj. Jay J. Morrow, Colin H. Ingersoll, and Alfred H. Brooks. (UAF, 1979-0041-00098.)

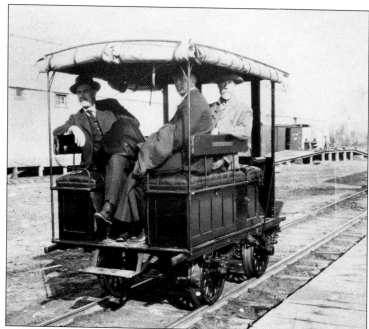

Two men ride in a little track car high on the ridge separating Goldstream from the Chatanika River. The photographer and his equipment must also have found a seat on this little track car, as it is so high up on the ridge. (UAF, 1979-0041-00097.)

This photograph looks up Goldstream Creek along the tracks just before Gilmore Creek (from the right) and Pedro Creek join to form it. The large building is the Loop Roadhouse. The photographer is looking back down the loop toward Fairbanks. By 1914, the AEC had surveyed the TVRR, and by February 1916, it had its own finished drawings of the railroad, foreshadowing its eventual purchase in 1917. (UAF, 1989-0166-00093.)

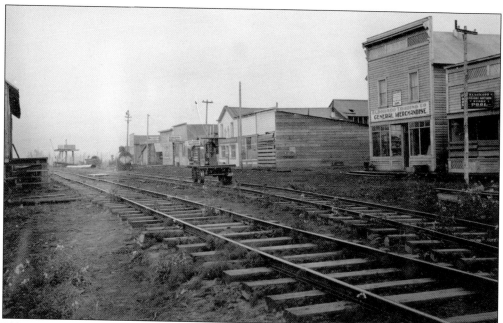

Eldorado's main street hosted the main line, a siding, and a handcar. Boarded-up stores, a weedy street, and no people make the town look abandoned. Power and telephone lines, however, show some modern comforts. Perhaps the population is all in the pool hall on the right next to the Eldorado Trading Company. There is a water tank in the left distance. (UAF, 2004-0085-00002.)

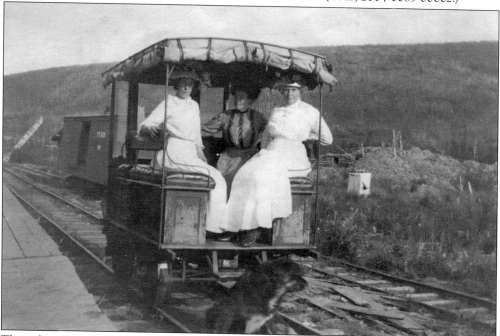

These three well-dressed ladies look comfortable, although the dog in the foreground may be camera shy. Behind them, TVRR boxcar No. 111 rides on a slight tilt, a result of track conditions due to melting permafrost and the lack of ballast. Boxcar No. 111 has a stove vent, indicating that it was used in winter as a hot car, holding goods that could not freeze. (Waugaman, 12-01_0013.)

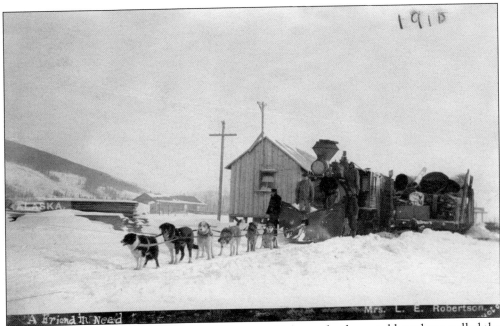

This 1910 photograph, "A Friend in Need," is a posed joke, as the dogs could not have pulled the engine behind them. The engine is cold and parked at Eldorado—note the icicles on the cab windows, the stack lid, and the lack of smoke. (Waugaman, 12-01_0098.)

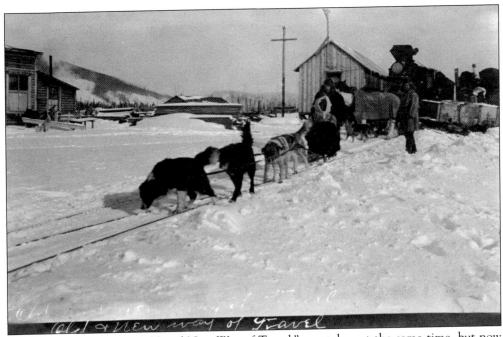

This photograph, titled "Old and New Way of Travel," was taken at the same time, but now there is a three-dog sled pulling a passenger, with a musher standing behind the sled. Behind the musher, a team pulls a water sled. (Waugaman, 12-02-26_0055.)

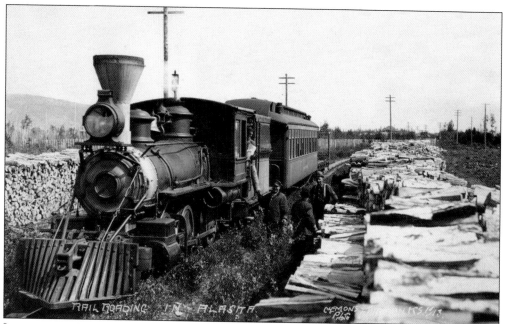

Locomotive No. 51, a 2-6-0 Baldwin, is seen here at a woodpile outside the Fairbanks yard. Handing up the wood one log at a time would have been quite a chore—it was likely performed just for the camera. (UAF, 1961-0973-00027.)

Frank Carpenter (pictured) described this as Fairbanks's annual 20-acre woodpile. An enormous quantity of wood was used to run the city, which had electric power, telephones, and other modern conveniences powered purely by wood. The area eventually experienced difficulty in procuring wood, but Fairbanks was saved from fuel starvation when the government railroad brought in coal. (Library of Congress, Frank and Frances Carpenter Collection, 01968u.)

Little Engine No. 1, formerly of the North American Trading & Transportation Company (NAT&T) coal mine, arrived at Chena City via steamboat on July 4, 1905, becoming TMR No. 1. It was built by the H.K. Porter Company of Pittsburgh on January 12, 1899, with builder's number 1972. Built as factory stock, it was held as stock until May 5, 1899, when it was sold to NAT&T. The workmen at Porter were fast, as the factory records report it being taken apart and boxed for export by May 10, 1899. This is a rare historical image, as the builder's number is readable with an enlargement. Because it has had many owners and the cab was modified due to accidents, identifying it in old photographs has become an art. Reliable identifying marks are the broken saddle-tank step and the extended smoke box. In most images, the cab looks as if it has taken a beating and been rebuilt differently. Here, it is at Chena, parked behind passenger car TMR No. 100. Currently, No. 1 has been restored to operation and looks better than it did in 1913. (Waugaman, 10-Jun 2012_0000a.)

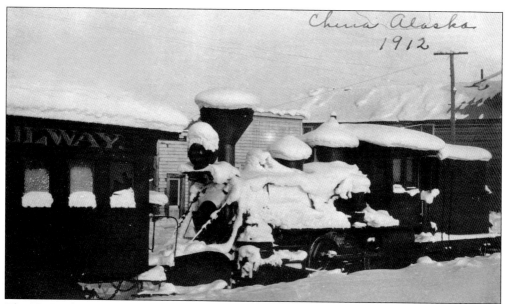

The TVRR had limited engine house space, with only two small houses for locomotives, two engine stalls at Chena, and one engine stall at Fairbanks. The TVRR must have had surplus equipment during the winters, as this cold-looking coach and engine No. 50, a 4-4-0 from Baldwin, were stored at the time of this photograph. (Waugaman, 10-Jun 2012_0001a.)

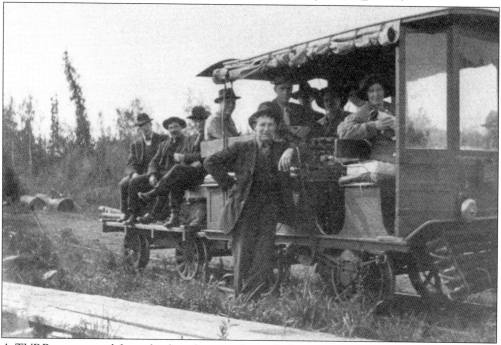

A TVRR gas car and four-wheel trailer provide a ride for 10 passengers. The hydraulic mining pipe in the background, the weeds, and the primitive station platform of only three planks indicate that this was a small, basic stop. Springs supplied some comfort on the gas car, while the un-sprung trailer would have tested the padding of the men on the rough track of the TVRR. (Colin MacDonald, Deely collection, 0035a.)

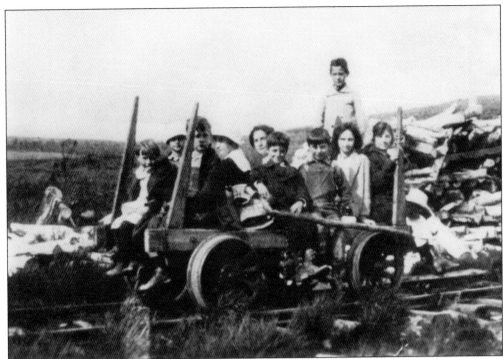

A school train is seen here in Fox in the late 1920s. It seems that every early photograph has piles of firewood and denuded hills for a background. After all the wood in the area had been cut, the arrival of coal to Fairbanks via the Alaska Railroad saved the town. (Olga Steger, Deely collection.)

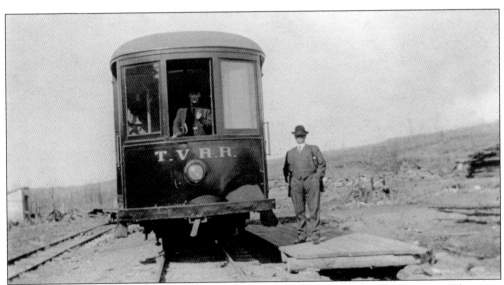

TVRR's battery-powered electric passenger car is seen here at an unknown location. There are tracks to the left and right of the car, and a utility pole on the right ridge. This post–gold rush scene shows the hills cleared of trees for firewood. The dents in the car are likely from the many times it was reported derailed in the newspaper. (Waugaman, Deely collection, 0004 a.)

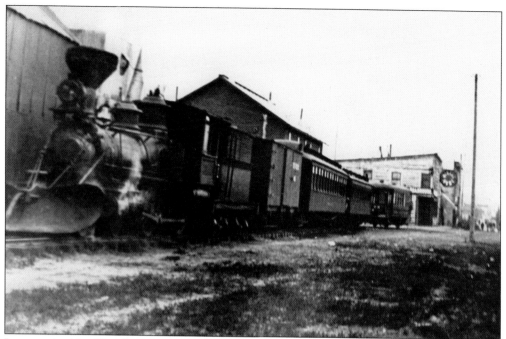

Locomotive No. 50 pulls a train out of the Fairbanks station and just past the water tower. No. 50 is prepared for winter, with its snowplow attached. To the rear is the battery electric car. The last building in the distance is the Miner's Home, a hotel and restaurant. This location has been called North Turner Street and Park Street, but is presently the north end of the Barnette Street Bridge. (Waugaman, Deely collection, 0027a.)

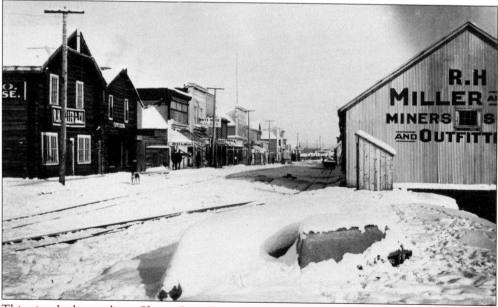

This view looks north on Chena City's Front Street in winter. There is a two-track yard in the middle of the street. R.H. Miller & Co. is on both sides of the street, and on the left side are an unnamed restaurant, the White Horse Restaurant and Saloon, and the Californian saloon and hotel. (UAF, 1979-0106-00008.)

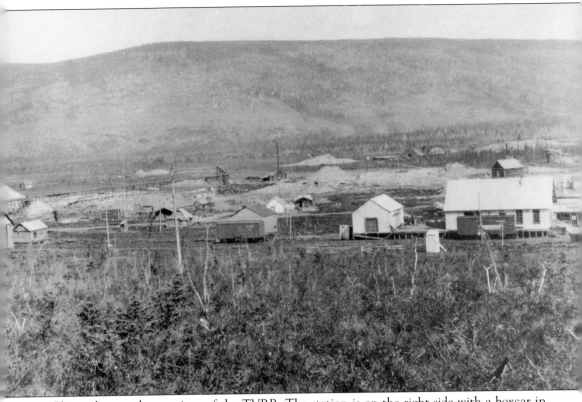

Chatanika was the terminus of the TVRR. The station is on the right side with a boxcar in front, and most of the town is out of the image farther to the right. The universal outhouse is towards the photographer, across the tracks from the station. Like most early scenes, there are no trees near any buildings, all of them having been cut for fuel. Chatanika, 45 rail miles from Fairbanks, grew into a fairly large town after the railroad stopped here. The Washington Alaska Bank building is to the right of the station, across the street. This bank, originally founded by Falcon Joslin, failed after possibly corrupt practices by its new owner, E.T. Barnette, the founder of Fairbanks. The town was not listed in the 1907 Tanana Valley Directory. This station served Cleary City, many nearby creeks, and the mines in the river valley in the background. Note the two long, high sluices carrying water into the valley. Today, this same scene would be dominated by the Chatanika Dredge. (UAF, 1976-0092-00004-c.)

Five

OPERATIONS AND WRECKS OF THE TVRR

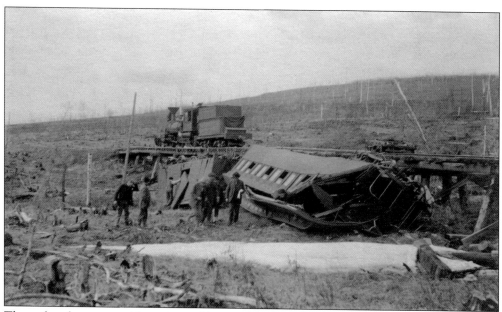

The railroad was not without its problems, and while financial problems dominated, wrecks were frequent. The Morino wreck, on May 15, 1916, was notable because coach No. 204 and a baggage car went off the trestle and were totally destroyed, but the passengers lived. One surviving passenger was George A. Parks, who took this and the following photographs of the wreck. Note Fred Jorgensen crawling out of the car. (Waugaman, 12-01_0083a.)

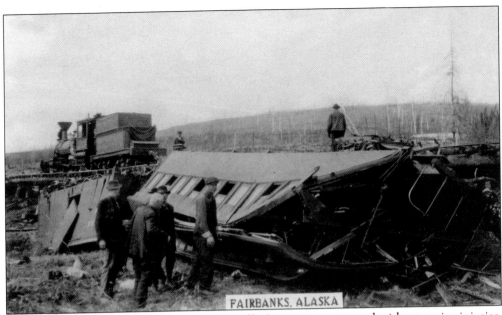

This is another view of the Mornio wreck. All 12 passengers escaped without major injuries. Engine No. 50 waits on the trestle. (Waugaman, 12-01_0010.)

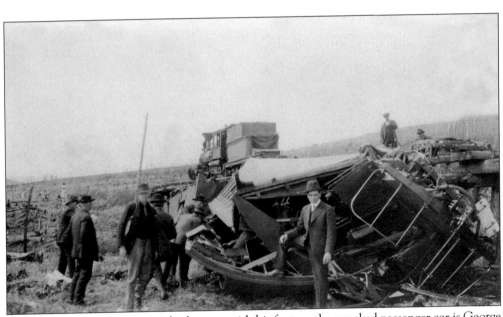

In this view of the Morino wreck, the man with his foot on the wrecked passenger car is George A. Parks. He was appointed governor of the Territory of Alaska in May 1925. The exact location of the wreck is not known, but Morino was between Ridgetop and Olnes, near Boxman Creek and milepost 32. (Waugaman, 12-01_0017.)

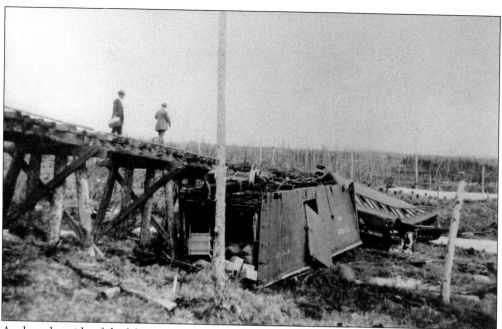

At the other side of the Morino wreck, the end of the boxcar came off, exposing the cargo. (Jim Brown, Deely collection, 0021a.)

This ticket was issued during the TMR period, before the name was changed to TVRR and before tracks were built to Ridgetop station, which was later TVRR's transfer point for Dome or Vault. This ticket was good for stage travel from Dome City to Fox and on to Fairbanks. (Waugaman, 12-01_0091B&W.)

CLEVELAND STAGE LINE

Tanana Mines Railroad Co.

Good for one Continuous Passage on date of sale only

FROM

DOME CITY

TO

FAIRBANKS

VIA FOX

When Stamped by Selling Agent

Cleveland Stage Line assumes no responsibility beyond its own line.

No. 183 CLEVELAND STAGE LINE

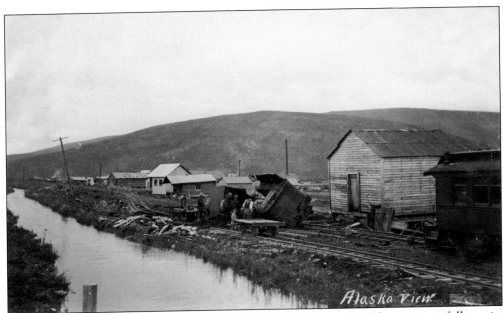

This wreck on the line was at a passing siding very near Chatanika. The engine is fully on its side, and the tender is at 45 degrees, uncoupled from the passenger car. The wreck appears to have been caused by soft ground. "Alaska View" was the trade name of photographer Lorenzo. E. Robertson. (Waugaman, 12-01-0041.)

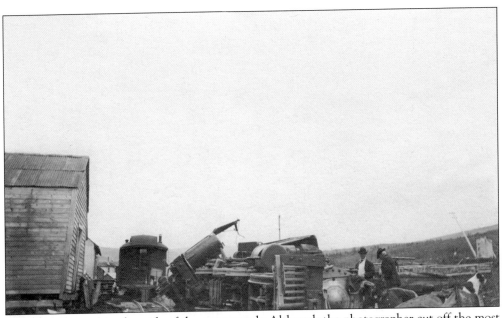

This view shows the other side of the same wreck. Although the photographer cut off the most interesting thing, the engine, the image still shows the bottom of the tipped-over locomotive, revealing that it is a 2-6-0 with blind (flangeless) center-driver wheels and a Stephenson valve gear. This information leaves little doubt that it is either Engine No. 51 or No. 52. (Waugaman, 12-01-42.)

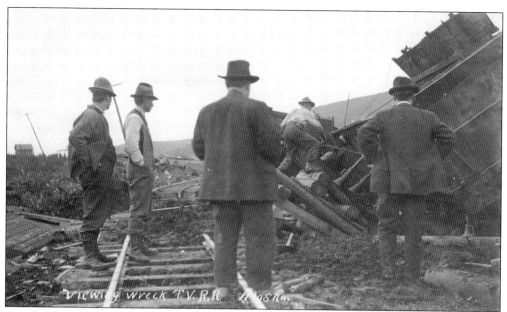

Another view of the wreck seen on the previous page, this image indicates melting permafrost. Timber cribbing and jacks are being used to right the tender. Notice the tilt of the tracks where the men are standing. With four persons with hands in their pockets, the scene is complete—laborers working and executives watching. (Waugaman 12-01-0043.)

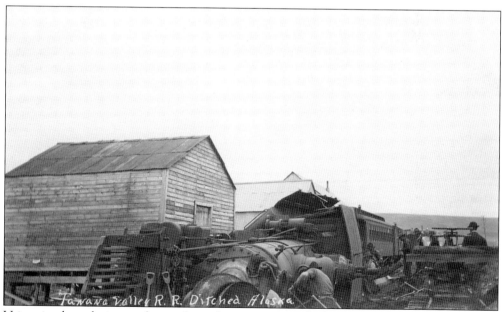

Using simple tools, it must have taken a long time to tip the locomotive back over. This image shows that the funnel stack has been removed and that the bell is in front of the sand dome. Engine No. 51 had its bell between the sand dome and the steam dome, making this Engine No. 52. (Waugaman, 12-01_0033.)

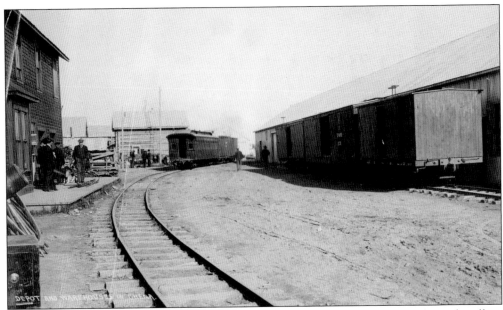

Titled "Depot and Warehouse in Chena," this photograph shows almost all of the early rolling stock. A large floor safe is just visible on the left, in the dirt; farther back, on the Chena depot's deck, are several ladies and a gentlemen. The large building to the right is the railroad's warehouse. (Joslin collection, UAF 1979-0041-0169.)

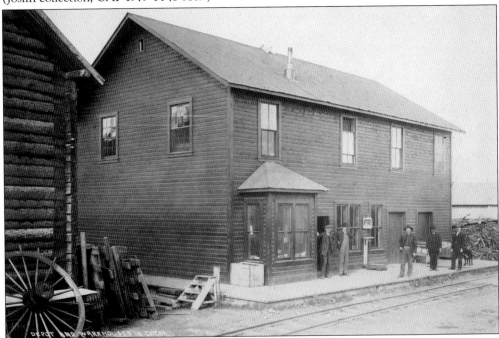

In this image, the Chena station looks similar to the Fairbanks station. The riverboat helm is not a part of the railroad. The stairs to nowhere on the left of the station were used to ascend into the cars. Five gentlemen are posing for the photographer with a scale to weigh freight between them. Supplies of firewood for the locomotives are piled up behind the dog at the rear of the platform. (Joslin collection, UAF 1979-0041-0171.)

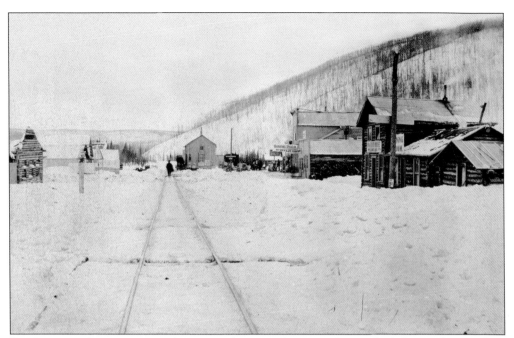

Fox City is seen here in its winter dressing. In the center distance is the metal-sided station house. There is a siding track that goes to the right of the station, but it is not visible. (UAF, 1989-0166-00949.)

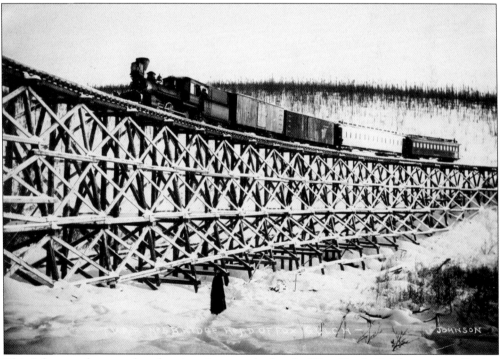

This Johnson photograph, taken in winter at the head of Fox Creek Gulch, captures Engine No. 51 on Trestle No. 5, a popular photographic point on the railroad. The spiky trees in the background are most likely burnt black spruce, too small to be useful in the mines. (Joslin collection, UAF 1979-0041-0067.)

Large and small hazards presented themselves to the railroad, including this porcupine near the TVRR tracks. Porcupines have been known to damage various wooden structures, although this one may have been headed for the stew pot. (Joslin collection, UAF 1979-0041-00025.)

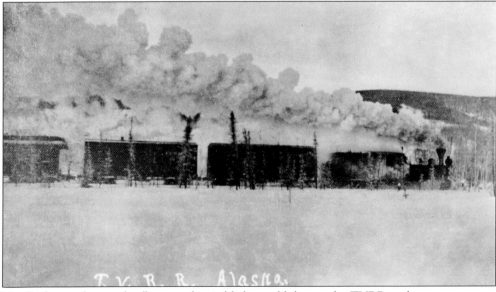

No. 51 charges fast on the flats on what is likely a cold day on the TVRR, as low temperatures condense steam. Interestingly, there is no plume from the heated boxcar that precedes the passenger car either. (Deely collection, 0017b.)

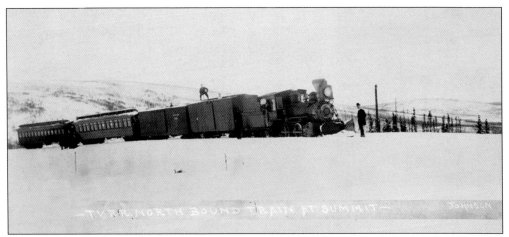

No. 51 pulls two coaches and converted boxcars on the summit between Fox and Olnes. There is extra siding raised above the tender, in order to hold more wood for the hard run up the hill. (Joslin collection, UAF 1979-0041-0040.)

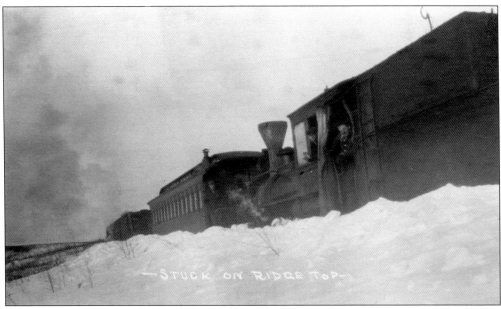

The title of this photograph says it all: "Stuck on Ridge Top." Even double heading was not enough to keep the train from getting stuck. Ridge Top was a station just over the top of the divide between Fox and Olnes, where high winds often caused drifts. The stance and look of the cab crew clearly indicates their disgust. (Waugaman, 12-01_0008.)

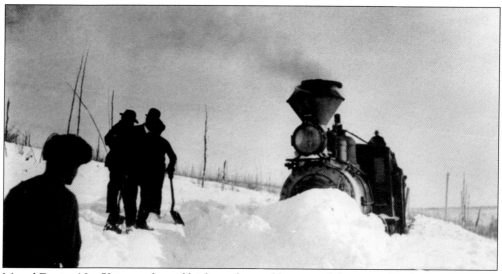

Mogul Engine No. 52 is snowbound high on the road between Gilmore and Ridge Top, near the summit. While TMR's locomotives had snowplows, a crew of men and shovels was frequently the only way a train could make the passage over the wind-blown summit. (Bruce Halderman, Deely collection, 0012a.)

Hard times meant that there were no funds to add ballast or do maintenance. With bark to hold in moisture and no gravel to keep the ties dry, the spruce-wood ties rotted. Only the flotation on the wetland bottoms kept the rails above the bogs. The track looks level, but it was different when weighted by a train. (UAF, 1979-0041-00102-c.)

The *Alaska Citizen* had fun at the expense of the TVRR in this cartoon, lampooning the flooding that often hindered the railroad. However, Mother Nature did treat the TVRR rather badly, with floods and melting permafrost making maintenance operations expensive. The image below shows just how the floods affected the TVRR. (FTVRR collection.)

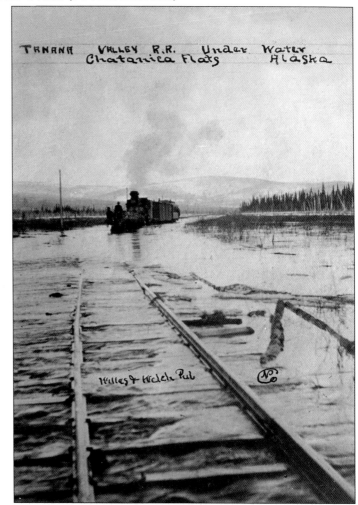

The little railroad had to contend with frequent floods during spring thaws. Here, a train is slowly pushing a flatcar ahead of the locomotive for safety. The locomotive is pulling two boxcars and a coach from Fox towards Ester, but the flatcar will derail if something is wrong with the tracks. Note the swift current. (Waugaman, 12-01_0034.)

Tanana Valley R. R. Co.

Special Train Service

FOR THE 4TH OF JULY CELEBRATION, 1913

GOING TO FAIRBANKS--

LEAVES—	CHATANIKA	GILMORE	FOX	ESTER SIDING
JULY 2	7:00 am.	8:35 am. 4:05 pm.	8:50 am. 4:20 pm.	9:40 am. 4:55 pm.
JULY 3	7:00 am.	7:30 am. 8:35 am. 4:05 pm.	7:45 am. 8:50 am. 4:20 pm.	8:30 am. 9:40 am. 4:55 pm.
JULY 4	7:00 am.	7:30 am. 8:35 am. 11:00 am.	7:45 am. 8:50 am. 11:15 am.	8:30 am. 9:40 am. 12:05 pm.
JULY 5	7:00 am.	8:35 am. 4:05 pm.	8:50 am. 4:20 pm.	9:40 am. 4:55 pm.
JULY 6	7:00 am.	8:35 am. 4:05 pm.	8:50 am. 4:20 pm.	9:40 am. 4:55 pm.

RETURNING, LEAVE FAIRBANKS

FOR—	ESTER SIDING	FOX	GILMORE	CHATANIKA
JULY 2	9:20 am. 4:30 pm.	9:20 am. 4:30 pm.	9:20 am. 4:30 pm.	4:30 pm.
JULY 3	9:20 am. 4:30 pm.	9:20 am. 4:30 pm.	9:20 am. 4:30 pm.	4:30 pm.
JULY 4	9:20 am. 11:00 pm.	9:20 am. 11:00 pm.	9:20 am. 11:00 pm.	11:00 pm.
JULY 5	9:20 am. 4:30 pm. 6:00 pm.	9:20 am. 4:30 pm. 6:00 pm.	9:20 am. 4:30 pm. 6:00 pm.	4:30 pm.
JULY 6	9:20 am. 4:30 pm.	9:20 am. 4:30 pm.	9:20 am. 4:30 pm.	4:30 pm.

NO FREIGHT OF ANY KIND WILL BE HANDLED ON THE 4TH AND 5TH.

EXCURSION RATES

FROM CHATANIKA TO FAIRBANKS AND RETURN _____ $4.00
OLNES TO FAIRBANKS AND RETURN _____ $3.50
RIDGETOP TO FAIRBANKS AND RETURN _____ $3.00
GILMORE TO FAIRBANKS AND RETURN _____ $2.50
FOX TO FAIRBANKS AND RETURN _____ $1.75

TICKETS ON SALE JULY 2ND, 3RD AND 4TH. GOOD TO RETURN TO JULY 6TH INCLUSIVE.

FAIRBANKS, ALASKA JUNE 26-13.

C. W. JOYNT, Gen. Mgr.

Summer was one long workday for gold miners, with nearly 24-hour daylight. The sluicing season was limited by the availability of water, so miners seldom took a day off. However, the Fourth of July was an exception, as businesses closed and all partied, a practice that lasted until the mid-1970s in Fairbanks. No freight was handled on the holiday, and only departure times were listed. (FTVRR collection.)

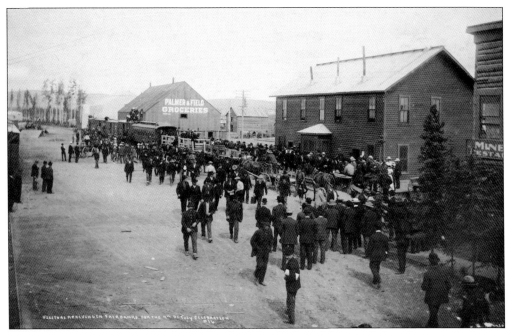

Titled "Visitors arriving in Fairbanks for the 4th of July Celebration," this photograph shows a train recently arrived from the gold creeks. The consist is an engine, three boxcars/baggage cars, a coach, and two flatcars, one with boxes and benches used as chairs. Everyone is well dressed for the celebration. The lack of a water tower and a limited number of passenger cars indicates that this is early, probably around 1906. (UAF, 1977-0089-00023.)

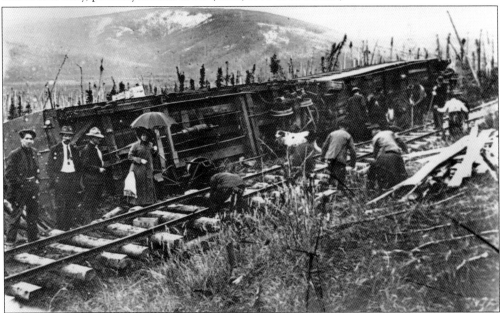

With a boxcar and a passenger car on their sides, 15 men and one woman with an umbrella are either working on the track or watching the others work. This accident may have happened in the fall, as indicated by a dusting of snow on the distant hill. (Colin MacDonald, Deely collection, 0014a.)

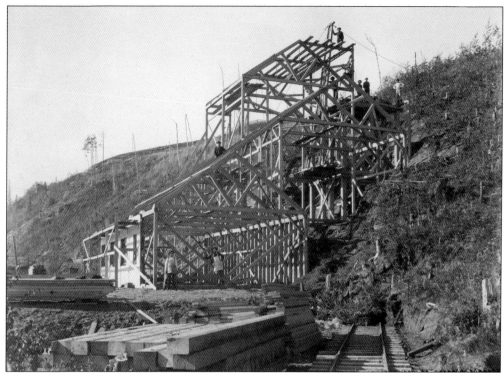

Building the Chena Mill, a stamp mill, in 1910 was Martin Harrais's attempt to save his dwindling town of Chena by processing hard-rock gold ores. The tracks in the photograph above may have been temporary. The Chena Milling, Smelting & Refining Company had 10 stamp mills and burned wood for power. Since there were no mines near Chena, all ore had to be hauled to the mill from distant mines via the TVRR or horse-drawn wagons. Fairbanks and Chena both suffered from declining placer gold mining, and many thought that hard-rock gold would soon be discovered in quantity, as it had been in other mining districts. (Above, UAF, 1966-0055-00001; below, Waugaman, 12-02-26_0014.)

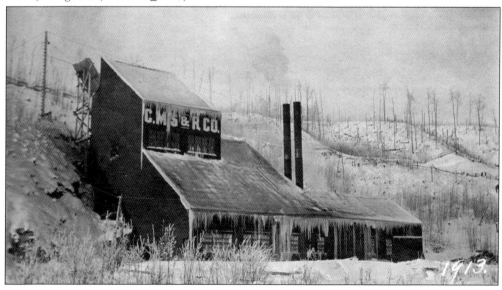

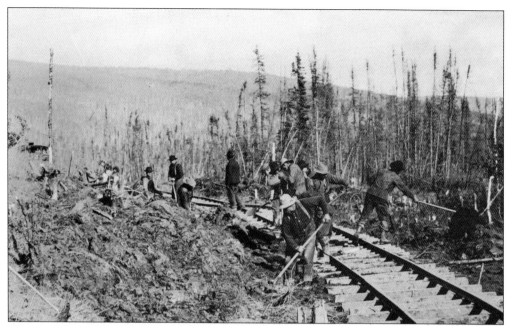

The track from Gilmore ran high above Goldstream Valley near Fox, on its way to Ridge Top. It appears that melting permafrost has pushed the track out from the cut, created a serious dip, and made this track gang of 12 busy. There is an engine with only its roof showing beyond the crew, to the left. (UAF, 1979-0041-00042.)

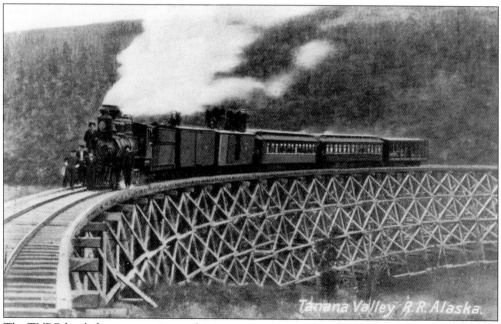

The TVRR hauled many excursions; this is one, complete with an "excursion view car" stopped on the Fox Gulch Bridge for the photographer. A group of passengers show their disregard for safety by standing on the roof of the boxcars. Mining was very dangerous in Fairbanks—there were 40 mining-related deaths per 1,000 people per year between 1905 and 1909. (Waugaman, 12-02-26_0017.)

This postcard, published for Chisholm & Hall's Bookstore in Fairbanks and titled "Winter Scene on the Tanana Mines RR Fairbanks, Alaska" must have been published in 1905 or 1906. It did not take long to denude the forest alongside the tracks for fuel. The skinny Black Spruce of interior Alaska make the narrow-gauge tracks look even closer together than 36 inches. (Waugaman, 12-02-26_0059.)

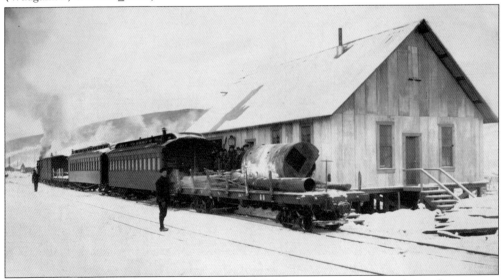

Chatanika station in seen here in the winter. The TVRR consist is an engine, one boxcar/baggage car, one flatcar, a passenger car, passenger No. 204, and flatcar No. 60, which carries a bundle of steel steam points for thawing mining ground, a large water pipe, and a boiler. (UAF, 1979-0041-00074.)

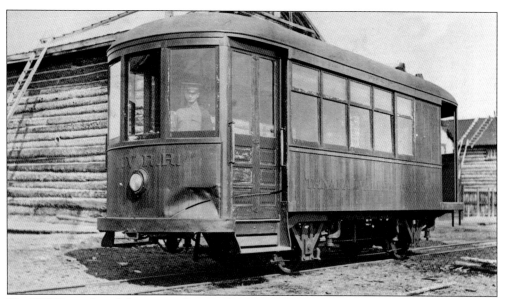

The TVRR purchased this storage battery electric car for runs from Fox to Chena and Fairbanks. Seen here at Chena, it could complete the trip without recharging. The sharp military-style uniform of the conductor is in contrast with the dent in the front of the car. The tracks to Chena were removed in 1919. (UAF, 1991-0046-00821.)

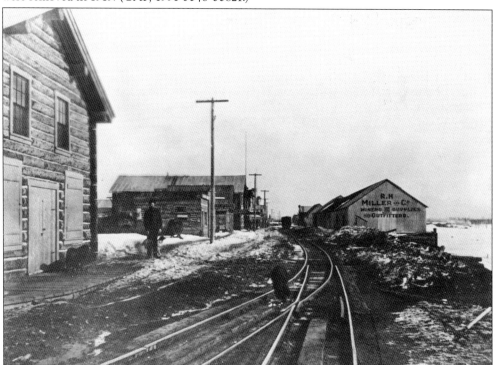

On Front Street in Chena, the rails on the left come from the engine house, and the ones on the right go past the engine house. The blunt ends of the rails at the switch in the middle distance indicate that the switch is a stub switch, which were soon outlawed as unsafe rail devices. From the looks of the dirty snow, this image was taken in late spring. (UAF, 1977-0026-00002.)

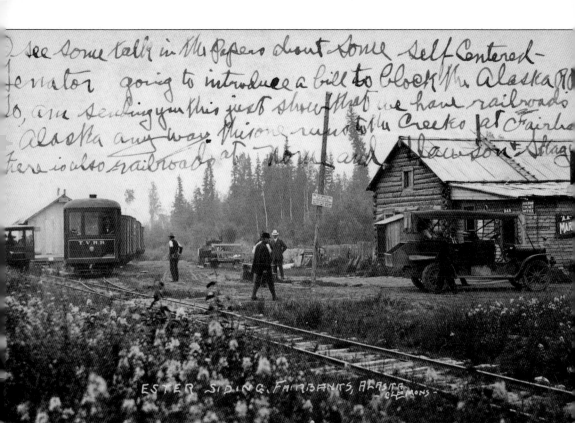

Ester Siding was the site of a planned branch to the towns of Ester and Berry and the diggings at Cripple Creek, but it was never built. Its present location is probably under the pavement near the Alaska Railroad crossing of Sheep Creek Road Extension. This postcard reads, "I see some talk in the papers about some Self-Centered-Senator going to introduce a bill to block the Alaska RR. So are sending you this just [to] show that we have railroads in Alaska anyway. This one runs to the creeks at Fairbanks. There is also railroads at Nome and Dawson & Skagway." The photographer has caught some busy action, as an inspection car appears loaded with passengers, the battery driven commuter car is in the station, and several gentlemen are proceeding to a ragtop automobile. (UAF, 1994-001-00024.)

G.F.O. NO 30 1910.

TANANA VALLEY RAILROAD COMPANY
FREIGHT TARIFF.
EFFECTIVE SEP 15 1910. CANCELS ALL CONFLICTING RATES.

MILES FROM CHENA AND FAIRBANKS	CLASS RATES IN CENTS PER 100 LBS BETWEEN CHENA AND (OR) FAIRBANKS AND POINTS NAMED BELOW	1. GENL MDSE HAY FEED &C CAR LOADS	2. GENL MDSE HAY & FEED LESS CAR LOADS	3. FURNITURE H.H GOODS LIGHT AND BULKY ARTICLES	4. LUMBER CAR LOADS PER 1000 FEET	5. LUMBER LESS CAR LOADS PER 1000 FEET
6	†ESTER SIDING	.20	.30	1.00	5.00	6.00
--	†ESTER CREEK	.50	.50	2.00	12.00	12.00
9	†HAPPY	PL	.92	1.25	SPL	8.00
13	†BIG ELDORADO	.35	.40	1.25	7.00	8.00
16	†ENGINEER	.35	.40	1.25	7.00	8.00
18	†FOX	.35	.40	1.25	7.00	8.00
--	†10 to 21 GOLDSTREAM	.60	.60	1.75	11.00	11.00
20	†TANK	.50	.60	1.50	12.00	14.00
21	GILMORE	.50	.60	1.50	12.00	14.00
29	†RIDGE TOP	.75	.90	2.00	15.00	17.00
32	†MORINO	.90	1.00	2.50	SPL	18.00
34	†OLNES	.90	1.00	2.50	16.00	18.00
--	†4 A TO 20 B DOME CR	1.25	1.25	3.00	22.00	22.00
38	†L. ELDORADO	.90	1.00	2.75	20.00	24.00
40	CHATANIKA	.90	1.00	2.75	20.00	24.00

MILEAGE TARIFF.

NOT EXCEEDING 8 MILES		.20	.30	1.00	5.00	6.00
" " 16 "		.35	.40	1.25	7.00	8.00
" " 24 "		.50	.60	1.50	12.00	14.00
" " 30 "		.75	.90	2.00	15.00	17.00
" " 36 "		.90	1.00	2.50	16.00	16.00
" " 40 "		.90	1.00	2.75	20.00	24.00

MINIMUM RATE ON 3 LBS OR LESS	25 Cts
" " 10 "	50 "
" " 20 "	75 "
" OVER 20 "	1.00

HIGH EXPLOSIVES SUCH AS DYNAMITE, POWDER, GIANT CAPS ETC 3 TIMES CLASS 2.

GASOLINE, NAPTHA BENZINE IN CASES OR TANKS 1½ TIMES CLASS 2. SUBJECT TO ...

LOCAL FREIGHT TARIFF.
IN CENTS PER 100 LBS BETWEEN
CHENA AND FAIRBANKS.

	L.C.L	C.L.
FURNITURE H.H. GOODS LIGHT AND BULKY ARTICLES	.75	.50
MERCHANDISE	.35	.25
LUMBER PER 1000 FEET	6.50	4.00
MINIMUM CHARGE 10 LBS OR LESS		.25
OVER 10 LBS		.50

RULES AND CONDITIONS.

POINTS MARKED † NO AGENT, FREIGHT MUST BE PREPAID AND IS ENTIRELY AT OWNERS RISK AFTER BEING UNLOADED FROM CARS.

PERISHABLES TAKEN AT OWNERS RISK OF FREEZING.

LIVE STOCK, HEAVY MACHINERY, BOILERS &c TAKEN BY SPECIAL ARRANGEMENT ONLY.

MINIMUM CAR LOAD 18000 LBS

FREIGHT WILL BE DELIVERED BY TEAM FROM ESTER SIDING TO ESTER CR POINTS, FROM FOX TO GOLDSTREAM POINTS AND FROM OLNES TO DOME CR POINTS SUBJECT TO DELAY.

EGGS IN CASES NOT CORDED AT OWNERS RISK OF BREAKAGE.

REPACKED CASES ARTICLES IN SACKS, DEMIJOHNS ETC WILL BE TAKEN AT OWNER RISK ONLY.

C.L. CAR LOAD. L.C.L LESS CAR LOAD.

WINDOW SASH, GLAZED DOORS CRATED TAKE CLASS 3.

FALCON JOSLIN.
PRESIDENT.

RECEIVED
OCT 23 1911
ANSWERED

C.W. JOYNT.
GENERAL MANAGER.

This is a Tanana Valley Railroad freight schedule for September 15, 1910. It states that charges from Fairbanks or Chena for "general merchandise" to Ester Siding is 30¢, and $1 per 100 pounds to the end of the line at Chatanika for amounts that were less than carloads. Explosives are charged three times those rates. It also says that delivery "points marked '+' [have] no agent, freight must be prepaid and is entirely at owners risk after being unloaded from cars." Note that only Gilmore and Chatanika fail to have the no-agent '+' sign. That also means that no station agent was present, so in those situations, the conductor acted as the station agent. Interestingly, Happy is included as a delivery point years before it became the junction for the Nenana Extension of the AEC. (FTVRR collection.)

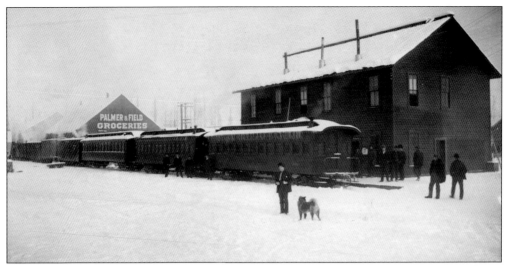

This image is titled "TVRR excursion train leaving Fairbanks" and shows the Fairbanks depot behind the last car. This image is from before 1913, because Palmer Fields was owned by E.R. Peoples after that. The three passenger cars, with No. 100 at the end, represented a large part of the TVRR's passenger-car stock. (UAF, 1989-0166-00178.)

speech and introduced the Governor. After the address dancing was indulged in, the Governor taking part.

ICICLE FALLS UPON MAN
AND FRACTURES HIS SKULL

Sudden Warm Spell Causes Peculiar and Probably Fatal Accident in Fairbanks.

TACOMA, Oct. 31.—A Fairbanks special says that the skull of A. Johnson, a sectionhand on the Tanana Mines Railroad, was fractured by an icicle dropping on him from the two-story depot building. He is not expected to live. A sudden warm spell thawed the ice.

This November 1, 1905, *San Francisco Call* clipping records the initial story of a man involved in an accident in the early years of the TMR. The man was later reported to have died. (Library of Congress.)

Tanana Valley Railroad Company

Time Table No. 13. Effective 12:01 a. m., May 10, 1909.

This Company reserves the right to vary from this Time Table at Pleasure

Chena and Fairbanks

North Bound Daily.		South Bound Daily.
No 7 Mixed		No. 8 Mixed
Lv. 7:00 a. m.Chena..................	Ar. 7:00 p. m.
Lv. 7:25 a. m.Junction................	Lv. 6:25 p. m.
Ar. 7:50 a. m.Fairbanks................	Lv. 6:00 p. m.

Fairbanks, Gilmore and Chatanika.

NORTH BOUND / SOUTH BOUND

NO. 1 Mixed Daily	NO. 3 Goldstream Special Daily	NO. 5. Chatanika Passenger. Daily		NO. 6 Fairbanks Passenger Daily	NO. 4. Goldstream Special Daily	NO. 2 Mixed Daily
A. M.	A. M.	P. M.		A. M.	P. M.	P. M.
9:30 Lv	11:00 Lv	3:40 Lv Fairbanks	10:00 Ar	2:30 Ar	5:30 Ar
9:45 M	11:15 Lv	3:55 Lv JunctionM	9:45 Lv	2:15 Lv	5:10 Lv
9:50 Lv	11:20 Lv	4:00 Lv Ester	9:40 Lv	2:10 Lv	5:00 Lv
10:25 Lv	11:50 Lv	4:30 MBig Eldorado ...	9:10 Lv	1:40 Lv	4:30 M
11:00 Lv	12:20pm	4:55 Lv Fox	8:45 Lv	1:10 Lv	3:50 Lv
11:20 Lv	12:30 Ar	5:10 Lv Gilmore	8:30 Lv	1:00 Lv	3:35 Lv
12:10pm		5:55 LvRidgetop	7:50 Lv		2:50 Lv
12:40 Lv		6:20 Lv Olnea	7:25 Lv		2:20 Lv
1:00 Lv		6:35 Lv	..Little Eldorado	7:10 Lv		2:00 Lv
1:10 Ar		6:45 Ar Chatanika	7:00 Lv		1:50 Lv

North bound Trains have right of track over South bound Trains.

FALCON JOSLIN, President. A. P. TYSON, Gen. Mgr.

Passengers holding tickets to points beyond Gilmore on trains No. 1 and 3 may stop over at Fox or Gilmore to train No. 5 on date of sale only; and passengers on train No. 6 holding tickets to Fairbanks may stop off at Fox or Gilmore until train No. 4 or No. 2 on date of sale only.

This TVRR timetable for May 1909 shows three trains going each way daily between Fairbanks and Chatanika. TVRR operated both mixed and passenger-only trains. (FTVRR collection.)

By the fall of 1912, the TVRR offered only one train each way per day between Chatanika and Fairbanks. The railroad maintained a Chena-Fairbanks run, but that was also limited to only one round trip per day. However, they did offer two round trips between Fairbanks and Gilmore on the "motor car." (FTVRR collection.)

The advertisement below is from the *Fairbanks Times* Industrial Edition, a special edition on April 3, 1910. During this period, the TVRR was actually earning a profit for its bondholders and shareholders. The issue contains a great snapshot of all Fairbanks industry and support services. In the advertisement, the phrase "operates teams" meant that they provided the last-mile delivery service via horses and teamsters. (Waugaman collection.)

Six

ACQUISITION BY THE ALASKA ENGINEERING COMMISSION

The TVRR eventually suffered from revenue losses and was purchased by the Alaska Engineering Commission. Here, at Ester Siding, the first stop north of Chena Junction, a passenger lies on the box on the right. (Waugaman, 23-09-2012_0010-c.)

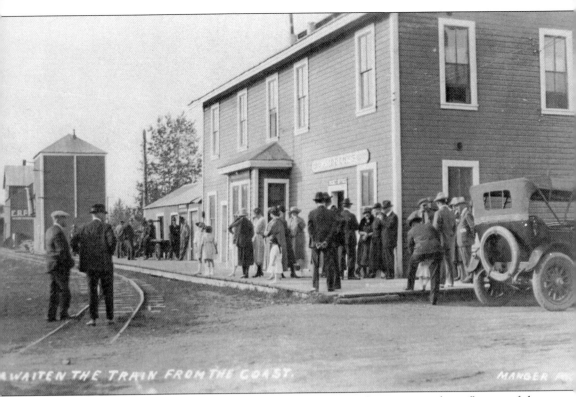

AWAITEN THE TRAIN FROM THE COAST. MANGER PH.

This photograph titled "Awaiten the Train From the Coast" demonstrates the influence of the AEC ownership, as both the station and the water tower are freshly painted. The sign shows the mileage to Seward, on the coast to Fairbanks. Once most of the rails were laid for the AEC, railroad passengers, but not trains themselves, were run from the coast, with gaps at Hurricane, Riley Creek, and Nenana. Passengers got through the gaps by horse, dogsled, or on foot. Therefore, this photograph is dated between 1919 and 1923, because the tracks are only narrow-gauge, Manger Photograph was not present in Fairbanks before 1919, and by then, trains were coming in "from the coast." (Waugaman, 12-02-26_0003.)

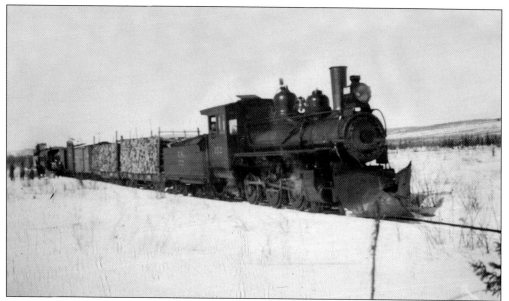

Engine No. 152 was purchased by the AEC to add power to the Tanana Valley Railroad, or the Nenana and Chatanika Extensions, as they were called by the AEC. No. 151 is pulling two cars of firewood, three boxcars, a flatcar, and a passenger car. (UAF, 1961-0973-00033.)

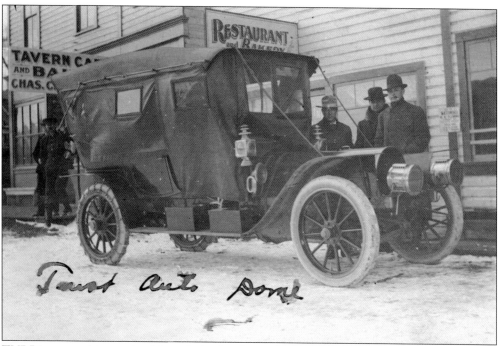

TVRR's competition arrived in style in the form of a 1908 Franklin, the first car to drive to Dome. The Franklin was owned by David Laiti and arrived in Fairbanks on the steamer *Cudahy* in August 1908. Behind the car, from left to right, are Baygerti, Matzgern, and Hosea H. Ross. This six-cylinder, 40-horsepower car was the second car in Fairbanks and was used for transport to the creeks from Fairbanks. (Waugaman, 12-02-26_0038-c.)

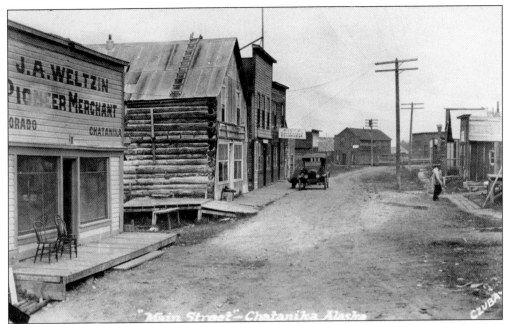

A rather slow-looking Chatanika is seen here; a town that does not look like it generates much revenue for the railroad. The automobile in the distance is literally driving the competition—and pushing the TVRR into bankruptcy. (Waugaman, 12-02-26_0064.)

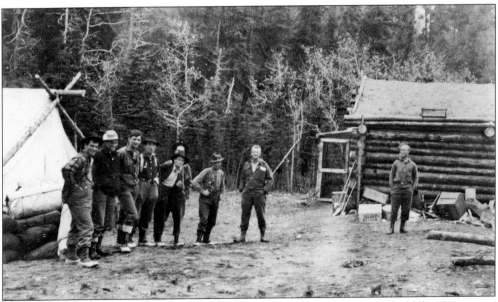

Steven Foster, the collector of the next few images, was one of the surveyors to build the Nenana-to-Fairbanks extension of the former TVRR, now owned by the AEC. This photograph was taken at North Nenana and shows the party starting out in September 1917. (UAF, 1969-0092-00553.)

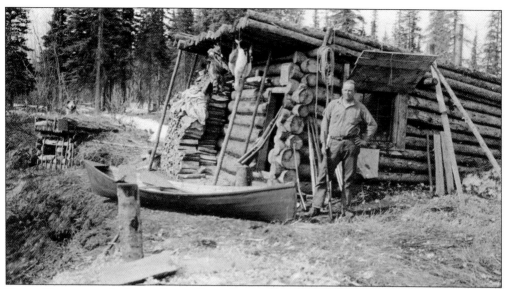

Steven Foster poses in front of one of his cabins. Note the shutter to keep bears out of the cabin and the canoe for transportation. (UAF, 1969-0092-00568.)

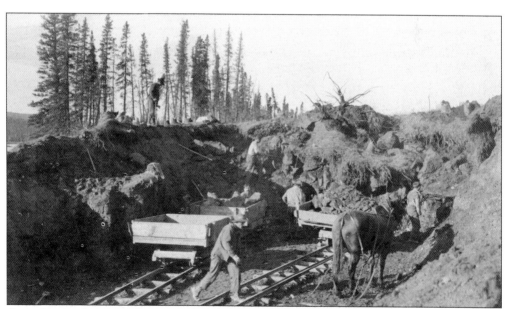

According to the original caption, this photograph shows "a cut being taken out one mile north of Nenana Crossing September 1917." This hard work broke both men and mules, but at least they did not have to worry about cave-ins, floods, and gas like in the gold mines. Here, the mosquitoes were the main hazard. (UAF, 1969-0092-00555.)

Steam-powered pile drivers like these—US No. 4 mounted on flatcar No. 905—were used to drive in supports for many small trestles and stream crossings. Later, gravel was dumped from railcars to fill the area under the trestle before the wood could rot. (UAF, 1969-0092-00501.)

After the narrow-gauge track from Happy to North Nenana was completed in November 1919, there were only a few gaps in the track from Seward to Fairbanks. One was the mighty Tanana River. Here, a group of passengers are transferring from Nenana to North Nenana on the stern-wheel river ferry *Midnight Sun*, owned and operated by the AEC. Freight was handled in the same way. (UAF, 1969-0092-00517.)

This White Pass & Yukon (WP&Y) route car, No. 206, was purchased by the AEC for use on the former TVRR line. It is seen here stored off the tracks at Nenana, awaiting freeze-up to cross the Tanana River. In the background, a crew assembles a railroad ditcher for the AEC. (UAF, 1969-0092-00521.)

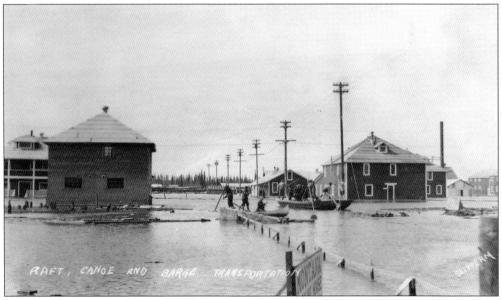

Nenana, like Fairbanks, also had an opportunity to become the "Chicago of the North," if only there had been sufficient business. It was located where the riverboats met the rails, and could serve all the traffic on the Yukon River. However, gold booms always bust at some point, and despite the infrastructure built by the AEC, the town never really grew. Frequent floods did not help its prospects either. (Waugaman, 10-Jun_0007c.)

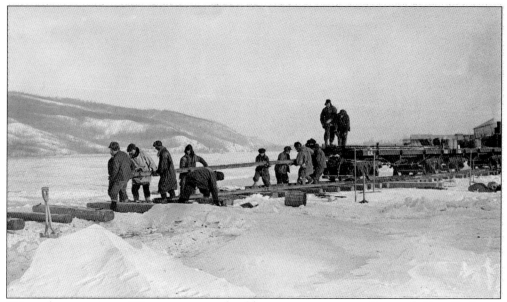

Winter ferry crossings at Nenana were not feasible, so narrow-gauge tracks were laid on the frozen Tanana River. Judging from these photographs, they used standard-gauge ties and fairly light rail. (UAF, 1969-0092-00533.)

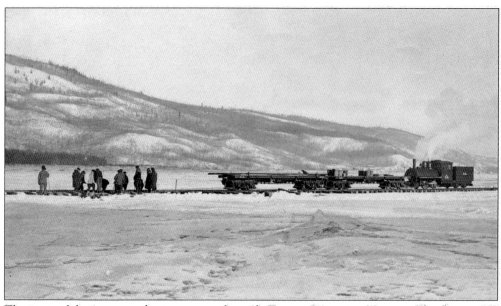

The ice-track-laying crew advances across the wide Tanana River near Nenana. The flatcars US No. 432 and US No. 430 are being pushed by the 0-4-4T US No. 6. The Tanana River Bridge was built in 1923 behind where the engine is. (UAF, 1969-0092-00532.)

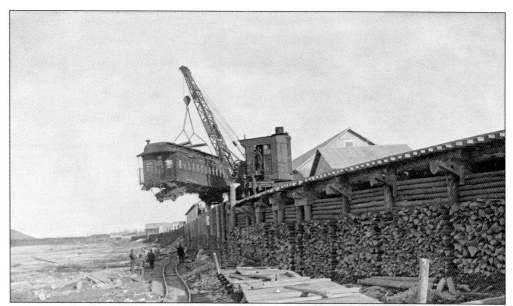

Above, narrow-gauge cars are lowered by steam crane on to the Tanana River ice from the Nenana dock. Former WP&Y narrow-gauge passenger car No. 206 is being lifted in preparation for use on the Fairbanks run. (UAF, 1969-0092-00530.)

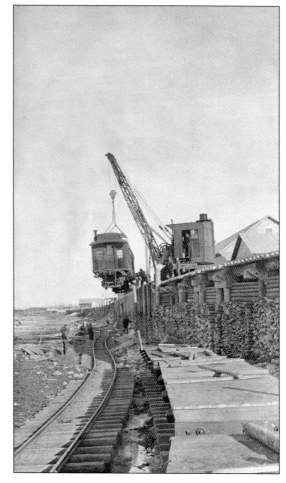

Here, three flatcars are already on the ice, and firewood for the wood-burning engines is stacked along the riverbank under the dock. It must have been interesting getting the wheels aligned with that curvy track. In the early days, rail employment was a quick path to injury or death. Pushing by hand, as seen here, certainly raised the chances of a fall. (UAF, 1969-0092-00531.)

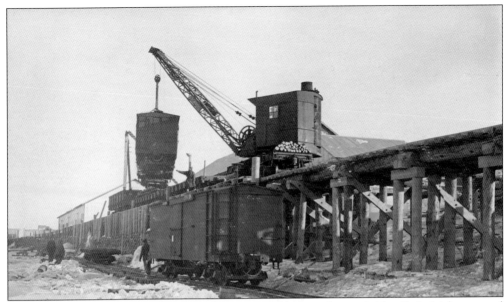

This consist of narrow-gauge boxcars being assembled on the ice-laid rails is fairly unusual in the history of railroading. A flatcar and former WP&Y boxcar No. 563 are already on the ice. (UAF, 1969-0092-00528.)

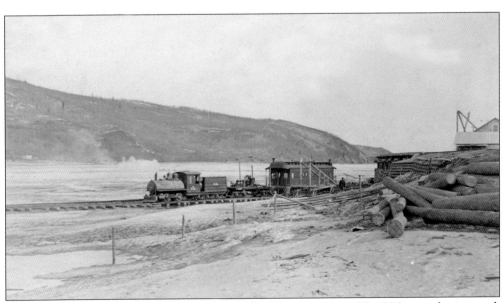

Locomotive US No. 6 leads flatcar US No. 407 and passenger car No. 206 onto the ice road. (UAF, 1969-0092-00539.)

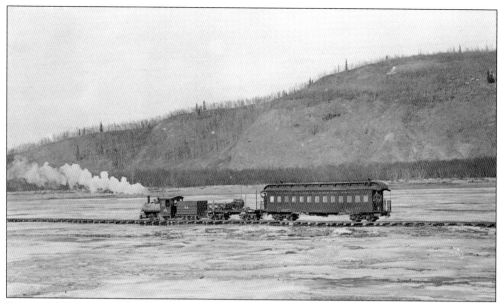

Engine No. 6 proceeds out onto the ice crossing of the Tanana River. Flatcar No. 407 carries the bucket arm of a railroad ditcher. The passenger car is still lettered for the WP&Y. (UAF, 1969-0092-00537.)

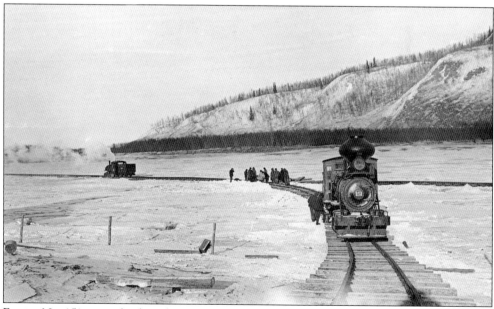

Engine No. 151 sits unfired on the ice spur, waiting for the numerous crewmembers to complete the track across the river. The crewmember nearest the camera wears a beautiful muskrat parka—with a coat like that, he is likely in a management position. The track leading to the right goes to the Nenana dock. Yard engine US No. 6 waits in the distance to move No. 151. (UAF, 1969-0092-00536.)

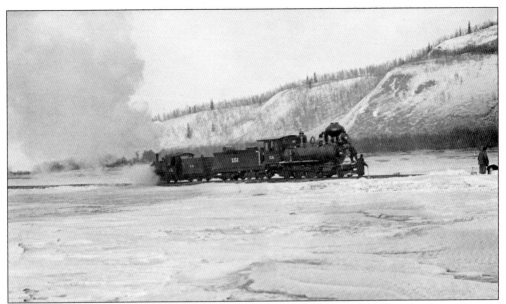

The US No. 6 0-4-0 narrow-gauge engine pushes No. 151 along track placed on the frozen Tanana River between Nenana (behind and to the right) and North Nenana (out of the photograph to the left). (UAF, 1969-0092-00534.)

This scene is probably at Nenana dock, with its well-maintained wooden deck surface. The large derrick crane served river barge transfers in summer and the ice track in winter. The gas car was used to transport passengers between Fairbanks and North Nenana for the AEC. Behind it is former TVRR boxcar No. 116, one flatcar, and another boxcar on this narrow-gauge spur. (UAF, 1969-0092-00916.)

Seven

ANOTHER GOLDEN SPIKE, TROUBLES, AND ABANDONMENT

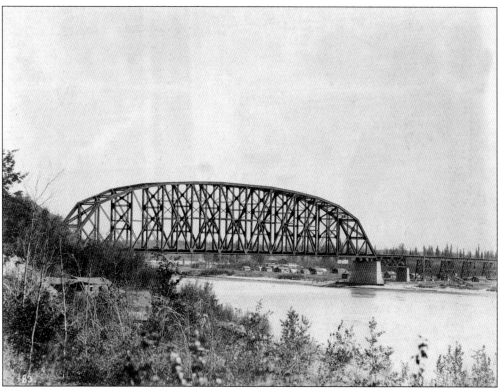

The bridge at Nenana over the Tanana River, completed on February 9, 1923, ended the practice of laying tracks on the ice each winter and barging during the summer. The narrow-gauge rails from Nenana to Happy were converted to standard gauge by June 15, 1923. The first through-train from the coast at Seward to Fairbanks was run on June 7, 1923, for a congressional inspection tour. Today, the bridge is named the Frederick Mears Memorial Bridge. At 704 feet long, it is the longest span in Alaska, and the third-longest simple truss in North America. (Waugaman, 23-09-2012_0003.)

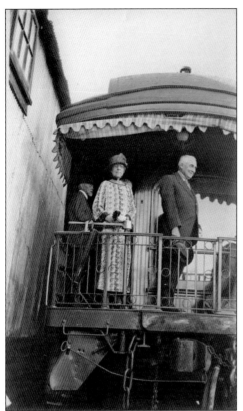

The Presidential Special arrived late in Fairbanks on July 15, 1923. Seen on the observation platform of the compartment-observation car *Denali* are Pres. Warren G. Harding (right) and first lady Florence Harding. The *Denali* was a Pullman compartment-observation car built to plan number 2028. Since Harding's visit, it has been modified and used for non-passenger purposes, but today, it is preserved at Pioneer Park in Fairbanks. (Waugaman, 12-01_0084.)

With the completion of the Tanana River Bridge and the standardization of the gauge, President Harding arrived in Nenana on July 15, 1923, to drive the golden spike, symbolizing the completion of the railroad. The presidential party is seen below leaving Nenana on the way to Fairbanks. (Waugaman, 23-09-2012_0000c.)

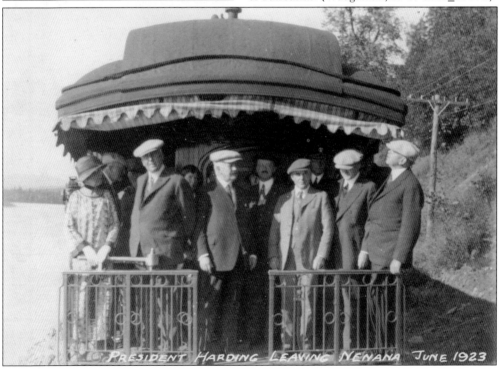

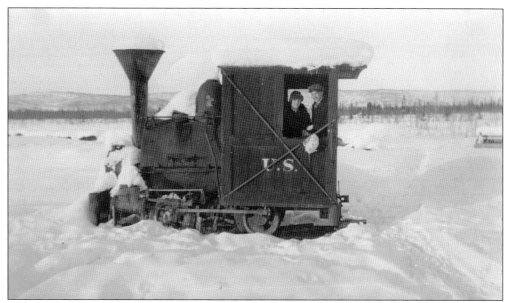

Former TMR and TVRR No. 1 was worn out and parked in Fairbanks after lots of hard work building the extension to Nenana. The AEC added "U.S." and the cross-braces to the cab. There is a "1" painted on the sand dome, but bullet holes make it almost unreadable. (Waugaman, 12-01_0012.)

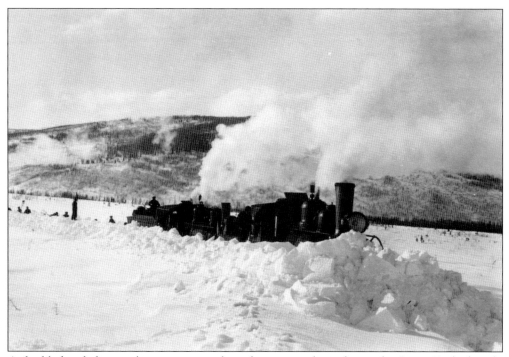

A double-headed snowplow train is stuck in deep snow along the tracks. James Rodenbaugh, who took this photograph, was a conductor with the TVRR, the AEC, and then the Alaska Railroad. He also invested in very early commercial airplane operations in Fairbanks. (UAF 1961-0973-00047.)

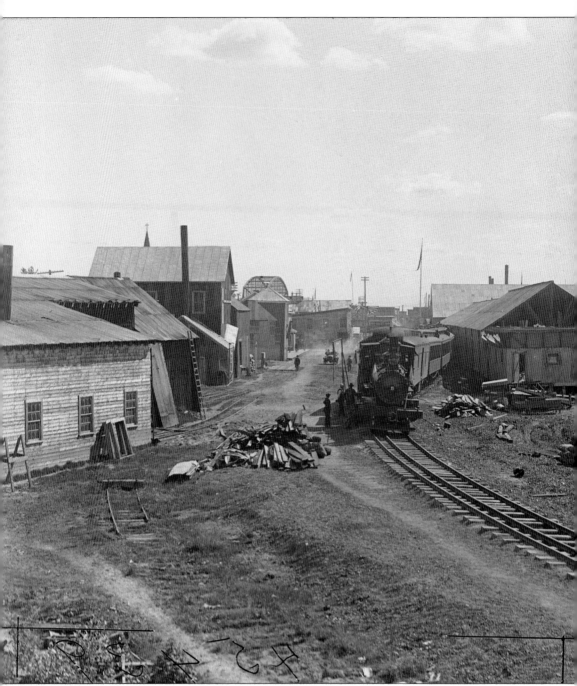

This stereo photograph was taken by D.L. Hollandy in 1923 for the Keystone Company. The image shows major changes in the Fairbanks rail yard. Three new rails for the main dual-gauge tracks are clearly seen. The rails still run down North Turner Street and contest ownership with a speeding car kicking up dust. In the left foreground are an engine shed and a machine shop, with their tracks partly removed. Next is the E.R. Peoples warehouse and the water tower hiding the original TMR depot. Last on the left is the log Miner's Home hotel and restaurant. The original narrow-gauge tracks in front of the depot have been removed. In the distance is the 1917 Cushman

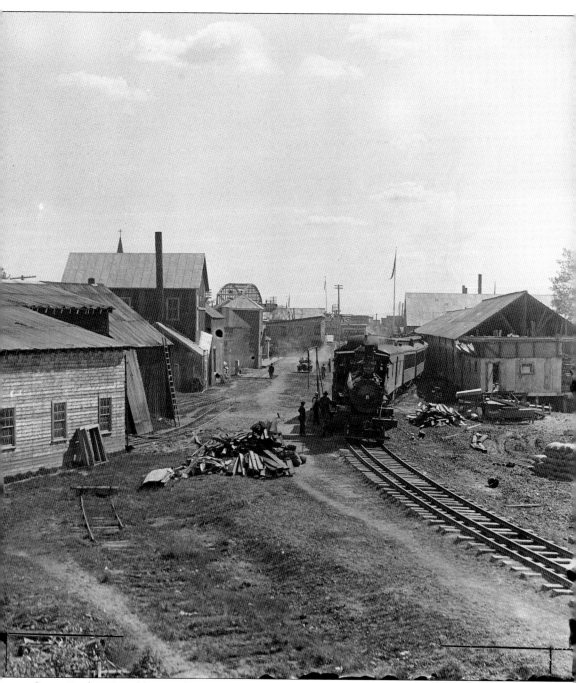

Street Bridge. An old TMR freight shed is being torn down on the right. AEC standard-gauge engine No. 11 is ready to pull a five-car train south from Fairbanks, with an American flag spread across the street and tracks. All the buildings on the left side of the tracks were taken down by the fall of 1923 for construction of the new Alaska Railroad depot. Since the tracks have been torn up in front of the old TMR depot, the image dates after June 22, 1923, but before September 15, when Fairbanks had a new temporary depot. (Keystone-Mast Collection, California Museum of Photography, University of California, Riverside, 1996.0009.KU45439.)

This image is an enigma; the tracks are lightweight and narrow-gauge. The first University of Alaska building (pictured) had its two end wings completed in 1925. In 1923, with the completion of the Alaska Railroad, the tracks by the campus were three-rail, dual-gauge tracks. There is a small building below the hill and behind the birch tree on the left. That may be the ARR's College Station on an all-new, dual-gauge main line. These are the old two-sided ties of the original TMR, with no sign of the standard-gauge tracks. (UAF, 1958-1026-00945.)

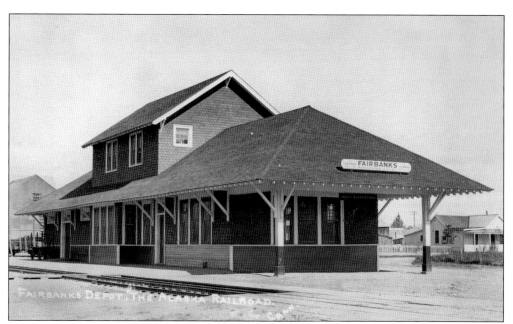

Construction began on Alaska Railroad's new Fairbanks depot (above) very soon after President Harding's visit in July 1923. Construction entailed the removal of many buildings from the railroad terminal grounds on the north bank of the Chena River. The depot was completed and in use by December 1923. (Waugaman, 12-01_0094.)

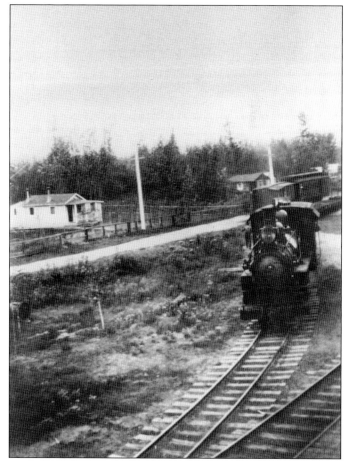

As the dual gauge main line came near Fairbanks, the narrow-gauge tracks— laid on standard-gauge ties—separated from the standard-gauge tracks and took a westerly route along the west side of the freight house before rejoining in gauntlet tracks just before the Fairbanks depot, as seen here. To the left of the train is what is now Driveway Street. (Clutch Lounsbury, Deely collection, 0031a.)

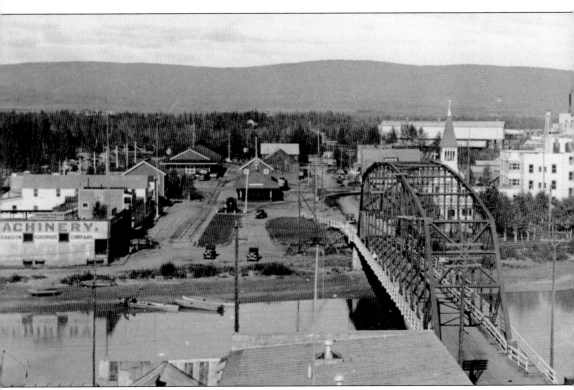

North across the Chena River from Fairbanks are Garden Island and the terminus of the Alaska Railroad (ARR). This Becker photograph was taken from the roof of the new Fairbanks Courthouse after 1933 but before 1935. The north end of the ARR's main line tracks runs toward the photographer in the middle left. In the center is the depot, and farther away across the tracks is the freight shed. Tracks run on both sides of the shed and rejoin at the depot's passenger platform. TVRR engine No. 1 is parked between the grass strip and the depot. The old TMR depot was moved across the main line tracks and became an ARR dormitory. The roof gables and trim on the three ARR buildings are painted "government white." (Waugaman, 12-02-26_0056-c.)

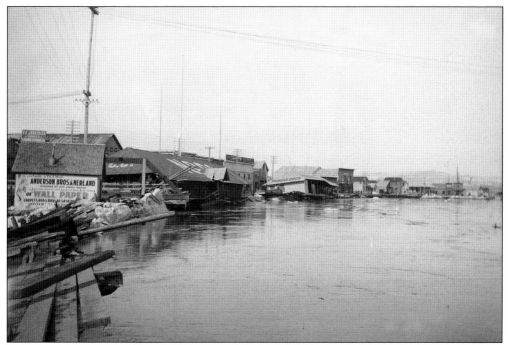

Floods were a common problem for Fairbanks and the TVRR. This spring flood sent thick ice crashing along the waterfront of Fairbanks, destroying docks and the bridge across the Chena to the railroad station. There is ice in front of the Anderson Bros. & Nerland store. Behind the store is the Cushman Street Bridge truss span, which was pulled from the river and saved. (UAF, 1968-0021-00090.)

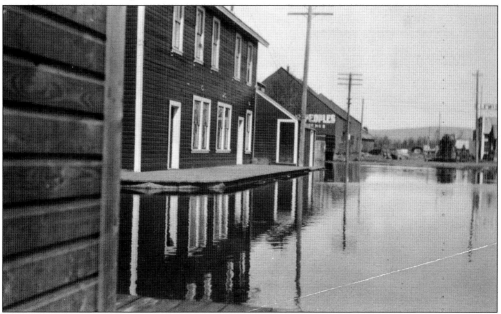

North of Fairbanks on Garden Island, the floodwaters spread out into the rail yards. Seen here are the Miner's Home restaurant and hotel, the white-trimmed train depot's street side, with its large entrance platform, and the large E.R. Peoples warehouse. (UAF, 1961-0973-00038.)

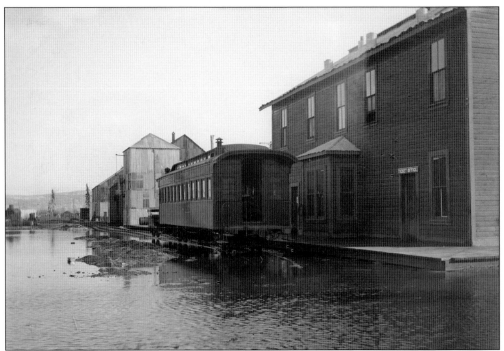

The rail side of the Fairbanks depot is flooded. The passenger car's painted road name, "Tanana Valley Railroad," is faded, just like the future of the railroad in the early 1910s. Peeking out from behind the passenger car is a small gasoline topless speeder. The insulated and heated square water tower is next, and beyond the dipping tracks near the warehouse is TVRR engine No. 1. (UAF, 1968-0021-00111.)

During spring thaws, ice ran in the rivers and jammed, causing many problems. Ice jams back up the water, causing floods, and then when the ice floats, it bulldozes buildings to splinters. The aftermath of such an event is seen here. (Waugaman, 12-02-26_0044.)

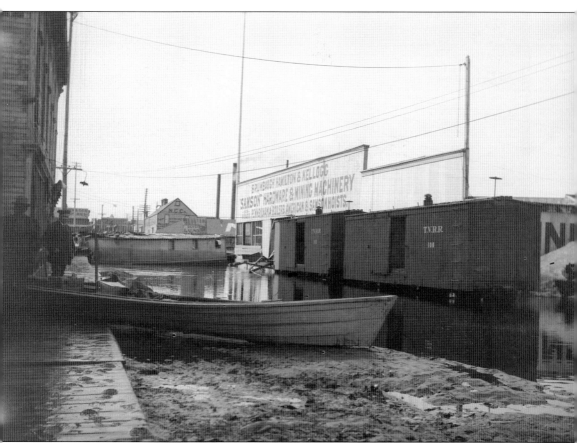

TVRR boxcars No. 100 and No. 112 wade in another flood. Both were hot cars—notice the stack from the woodstoves inside the cars. The low building in the center, complete with a high-water mark on its side, has floated in to block the river end of North Turner Street. For more than 100 years, the large store with the sign reading "Brumbaugh Hamilton and Kellog, 'Samson' Hardware & Mining Machinery" kept Fairbanks supplied. Muddy footprints on the wooden walk lead from a grounded and well-stocked rowboat. In the distance south across the river is the Northern Commercial Company's store, at the corner of First Avenue and Turner Street. (UAF, 1968-0021-00100.)

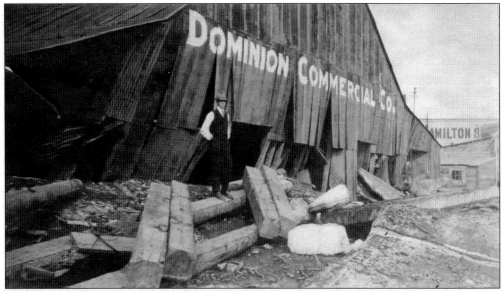

In another case of ice jam, this warehouse near the TVRR depot in Fairbanks suffered serious damage. The building was later purchased by the Northern Commercial Company, then Samson Hardware, and still stands today. (Waugaman, 12-02-26_0043.)

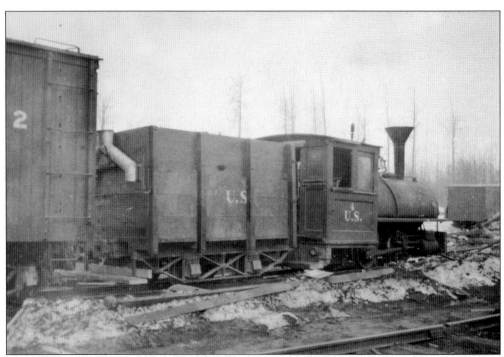

The Alaska Engineering Commission (AEC) brought new equipment to the ailing TVRR, including the dinky US No. 4 and this tender. This photograph was taken by W.E. Anger, the designer of the Tanana River Bridge at Nenana. (UAF, 1969-0089-00047.)

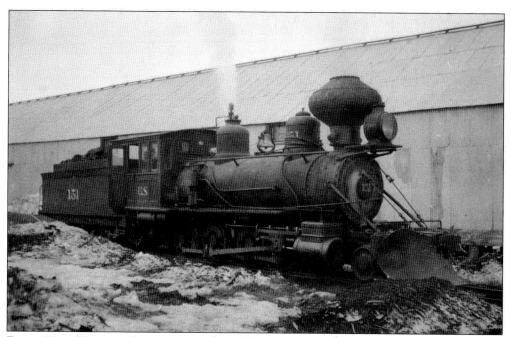

Engine No. 151 was another engine purchased for operation on the Fairbanks branch by the AEC. This photograph was also taken by W.E. Anger, during one of his two trips north to design the Tanana River Bridge at Nenana (now the Frederick Mears Memorial Bridge). Anger was a partner in the famous Modjeski & Anger engineering firm. (UAF, 1969-0089-00048.)

This photograph, taken from the Fairbanks depot platform, illustrates some of what W.E. Anger saw on his trip to Fairbanks, including the Miner's Home, a restaurant and hotel. The boxcars are US No. 114 and US No. 118 and the flatcar is US No. 42, with sides containing large lumps of coal. The flatcar with firewood in the foreground has unreadable road marks. (UAF, 1969-0089-00053.)

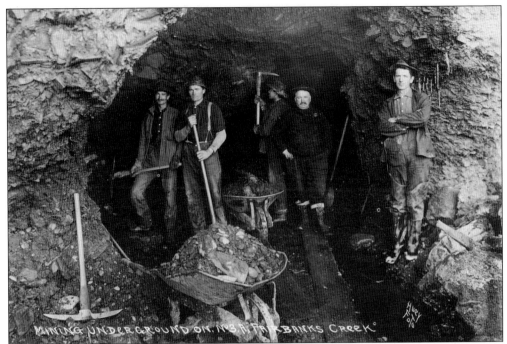

Mining dredges put an end to most underground mining in the Fairbanks district and further reduced traffic on the old TVRR, or Chatanika Branch, as the ARR called it. According to Rex Fisher, gold mining killed at least 83 people and injured more than 400 between 1906 and 1916. All it took in the pre–hard hat days was a little thawing to drop a rock. (UAF, 1979-0041-00143.)

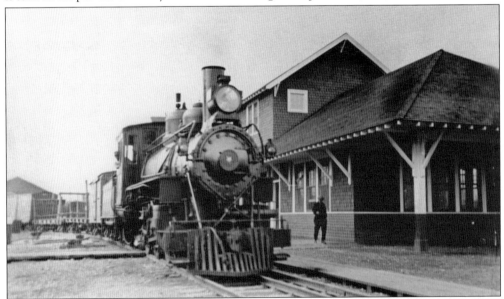

A standard-gauge engine is parked in front of the Fairbanks station. The three-rail tracks indicate that this photograph was taken between 1923 and 1930, most likely in 1923 or 1924 since there is not yet a station sign on the building and it looks new. This is the 1923 Fairbanks station, Fairbanks's second station. Today, Fairbanks uses its fourth railroad passenger station. (Waugaman, Deely collection, 0025a.)

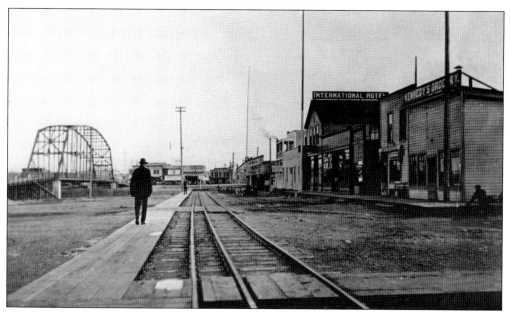

The northern end of the Alaska Railroad is seen here after 1923 and before 1930, when the narrow-gauge tracks were removed. The view looks south on North Turner Street, with the steel 1917 Cushman Street Bridge on the left. The first two businesses on the right are Kennedy's Grocery and the International Hotel. Samson's Hardware is the last building on the right. (Deely collection, 0029a.)

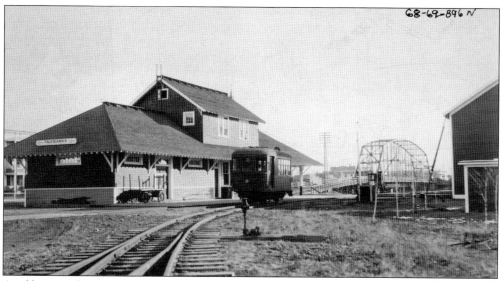

A self-powered narrow-gauge railcar is parked at the Fairbanks depot. The standard-gauge track comes in from the left, east of the freight shed, and joins the narrow-gauge in the foreground in a gauntlet track in front of the station. On the right edge is the original TMR station, which was moved across the tracks. (UAF, 1968-0069-00896.)

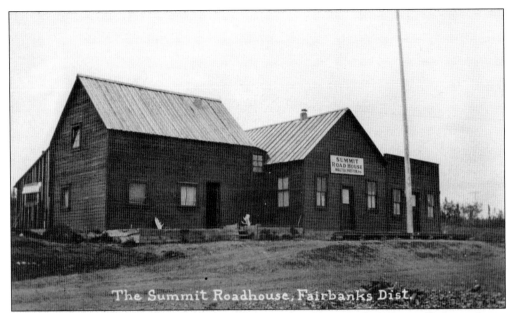

The Summit Roadhouse, Fairbanks Dist.

Summit Roadhouse was on the competing wagon road to Cleary, today's Steese Highway. It was built by the government's Alaska Road Commission and was a real threat to the railroad. As vehicles got better after World War I, freight went by truck in summer and by rail in winter. The high costs of operating the rail in winter without the summer revenues caused the Alaska Railroad to close the Chatanika Branch in August 1930. (Waugaman, 12-02-26_0065-c.)

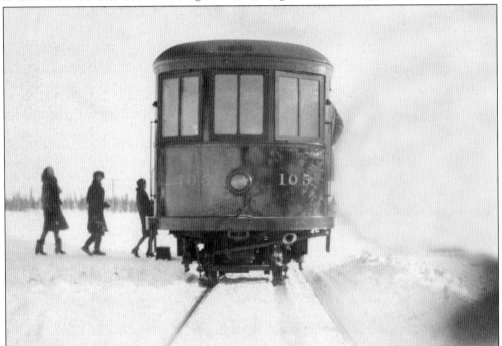

Passengers to and from the Alaska School of Agriculture College and School of Mines (now the University of Alaska) rode on this self-powered J.G. Brill Company narrow-gauge railcar, No. 105, between college and Fairbanks. (UAF, 1958-1026-01017-c.)

The Fairbanks depot is seen here in winter, dressed with icicles and 1940s cars. To the right is the Consumers Co-op, in the old E.R. Peoples building. This 1923 depot was torn down and replaced with a new one in 1960, which was built about where the co-op building is here. (Waugaman, 12-02-26_0061-c.)

Furs were a significant contributor to the economy of Fairbanks until the Great Depression. Loaded onto this baggage cart is $150,000 in furs brought by air to Fairbanks from Siberia, for shipment south on the railroad to the south coast on the Alaska Railroad. (Waugaman, 23-09-2012_0002c.).

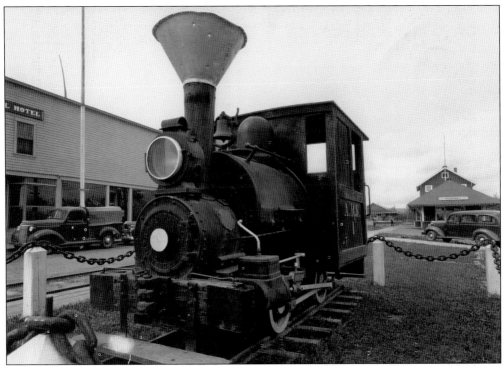

Engine No. 1, formerly of the Cliff Creek mine, the Coal Creek mine, the Tanana Mines Railway, and the Tanana Valley Railroad, was parked as a lawn ornament between the 1923 station and the Chena River on North Turner Street in Fairbanks for about 40 years. Even though other engines were scrapped, some farsighted and unnamed individuals saved the old H.K. Porter engine. In 1965, it was removed and transported to the Alaska Railroad shops in Anchorage for a cosmetic restoration. It returned to Fairbanks in 1967 to the Alaska Purchase centennial celebration site, now called Pioneer Park. After eight years of work, Engine No. 1 was restored in 2000 and is now operated by the Friends of the Tanana Valley Railroad. (Waugaman, 12-01_0045.)

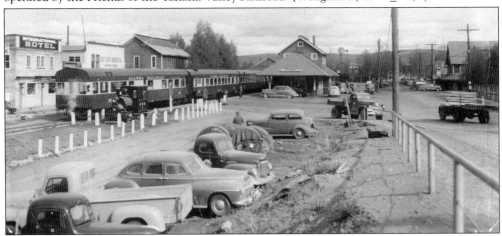

Little engine No. 1 is dwarfed by an ARR passenger train ready for a run to Anchorage. This image dates from the 1950s, because the new International Hotel was rebuilt after the fires of the 1940s, and the 1960 ARR depot was not yet built. The original TMR depot, by this time used as a railroad dormitory, stands across from the 1923 depot. (Waugaman, 23-09-2012_0008.)

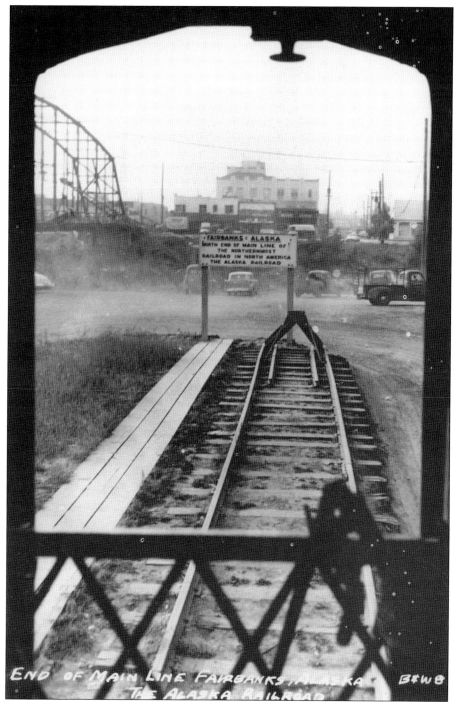

This sign reads "Fairbanks, Alaska: North End of Main Line of the Northernmost Railroad in North America, the Alaska Railroad." While this was true in the early 1950s, when this photograph was taken, and is still true today, it is still not connected by rail to the North American rail network. Falcon Joslin's dream of a rail connection through the Yukon Territory has not yet been realized. (Waugaman, 12-01_0095c.)

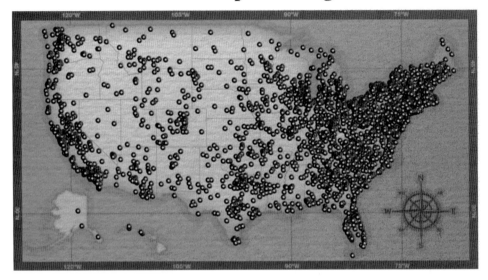
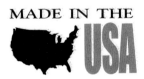